NATIONAL GEOGRAPHIC
PHOTOGRAPHY
FIELD GUIDE
BIRDS

NATIONAL GEOGRAPHIC
PHOTOGRAPHY FIELD GUIDE
BIRDS

SECRETS TO MAKING GREAT PICTURES

RULON E. SIMMONS
with BATES LITTLEHALES

A Bald Eagle swoops toward the photographer,
who fires a camera with a 300mm lens plus a
2x extender. The larger the bird, the better the
chances for flight shots—unless the large bird
flies as fast as this one.

Bates Littlehales

NATIONAL GEOGRAPHIC
WASHINGTON, D.C.

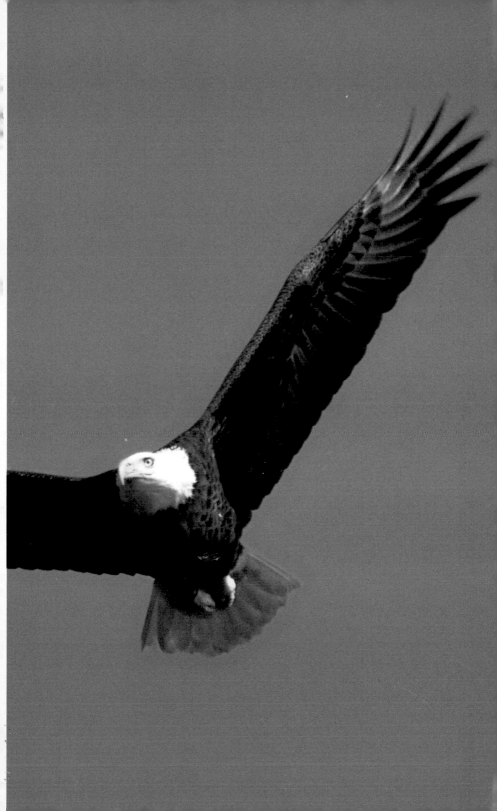

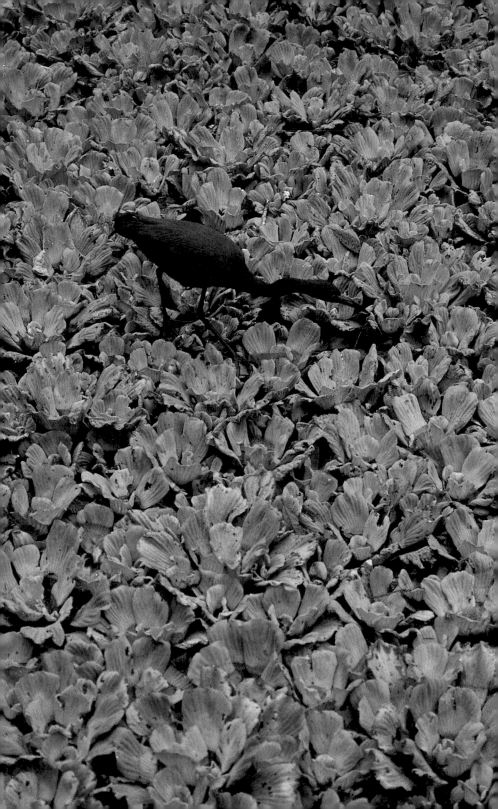

CONTENTS

OPPOSITE PAGE: A Little Blue Heron stalks food in a pond covered with water lettuce. The dense pattern of plants provides an interesting background and vivid contrast to the bird.

Bates Littlehales

Rulon E. Simmons

Heather Hoffman NGS

HAVE YOU EVER WONDERED how the experts take fantastic pictures of wildlife? Their photography may particularly amaze you if you have ever tried to approach a bird or other small animal only to have it fly or run away before you could even get close to it. In this book, you'll find the secrets of bird photography that I have discovered through research, experimentation, and lots of practical experience in the field.

This guide is designed to be helpful to amateur and serious nature photographers as well as bird-watchers (most prefer to be called birders) who want to pursue their interests through photography. It features photographic techniques, tips for getting close to birds, suggestions of great locations for finding "photographable" birds, and species-specific suggestions for getting pictures of birds. It also features many photographs, along with helpful information about how they were taken.

For more than 30 years, I have been interested in photography, particularly nature photography. During much of that time, I took photographs of flowers, large mammals, insects, and

amphibians with only an occasional photograph of a bird. Like many other photographers, I had the misconception that it was necessary to put up a blind at a nest to get good pictures of birds.

Putting up a blind requires considerable time and knowledge of bird behavior. It also risks upsetting birds while they are nesting. Nevertheless, in many publications on bird photography, the emphasis has been on this very technique.

I have since discovered that bird pictures can be taken using a variety of techniques, many of which are much easier than setting up a blind at a nest. Faster and sharper films and better camera equipment have opened up a wide range of possibilities. I'll discuss a number of different ways to get good bird pictures.

The keys to successful bird photography include proper selection of equipment, some understanding of animal behavior, knowledge of good locations for photography, and good timing. Each of these will be discussed on the pages of this book.

Using a combination of techniques discussed here, you should be able to take good bird pictures just about anywhere during all seasons of the year. With practice, I have been able to photograph well over 300 species of birds in my spare time.

Visiting good locations will enhance your opportunities for good bird photography. I've included some of my favorite sites in the United States and Canada.

In writing this photo field guide, I hope to show readers that bird photography need not remain the hobby of just a dedicated and persevering few, but can be enjoyed by all with a reasonable amount of effort.

Bates Littlehales

Heather Hoffman NGS

MOST PEOPLE HAVE HEARD the expression "free as a bird." Poetic as it may sound, it inaccurately describes the real life of a bird, who is governed by all sorts of rules and regulations put upon it by nature.

Some knowledge of these restrictions enables a bird photographer to think more like a bird than like a hunter trying to make a trophy shot of an elusive subject. Amassing this knowledge can be a lifetime quest. But it quickly shows up in your photography as marked improvement.

When I started out, I was thrilled just to get a sharp, colorful image of a bird. But I realized that editors wanted more than that. They wanted action and personality, behavior and excitement. They couldn't tell me how to get all this, but that's what they wanted. Fortunately I had access to experts in the field of ornithology and a background in the frantic pursuit of people photography plus sports, valuable experience for shooting pictures of birds, who are only occasionally frozen into still lifes.

My fascination with birds dates back to age 13 and never waned until romance and military experience demanded so much of my time. Now

I'm back to birds, without sacrificing the romance. Above all, though, I made time for trial and error. And patience? Let's call it maturation and interest.

Study, rather than try to compete with, the work of other bird photographers. Also study what wildlife painters do with birds: how they integrate them into compositions, into habitats and landscapes, how they hint at action and personality within the limitations of a still format.

Always remember that you are exploiting birds to photograph them. Exploitation need not be all bad. If you supply food and water, it's win/win exploitation. If you interrupt rhythms of courtship and nesting by your intrusion, it's bad exploitation. Awareness of the bird's life history will guide your ethics. When you think your photo is more important than consideration of the bird, you've become one of the bird "paparazzi." Editors might pay well for intruding on movie stars. But birds? Doubtful.

Perhaps you'll use your photography to collect new species, just as you would tick them off on your life list. I met a man in the field once who wouldn't list any bird he hadn't photographed. Game playing—but what fun!

Whatever photo games you play, keep an open mind for new approaches. Don't just play it safe with tried-and-true formulas. Take chances. Remember the cardinal rule of photography: "Thou shalt not bore thine audience." Work toward active, personality-filled images. Try to inject the same quality of life into your photographs that these marvelous little kinetic sculptures show you in the field.

If you do not immediately set the bird photography world afire, blame me. I'm responsible for the little boxes called "tips" that you will find throughout this book.

What Makes A Great Bird Photograph?

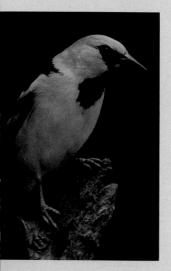

UNDERSTANDING AND working with bird behavior leads to more interesting bird photographs, but who's to say that great bird images must be filled with extreme action? A mockingbird "scaring" its prey with uplifted wings makes a strong image, but so does a robin with head cocked, looking (not listening!) for a worm.

An Altamira Oriole has plumage that screams "Look at me!" Often color alone is enough to dramatize a bird photograph—an attitude of impending action is a bonus.

Setting sun silhouettes an American Coot. The late light takes the photograph out of the ordinary without sacrificing the main idea—a water bird integrated into its habitat.

The image must be a powerful *photograph* to be an exceptional bird study. It must be composed well, but not necessarily in a conventional way. All the elements within the frame must work together without distractions to misguide the eye. Conventional rules are helpful, but don't become a slave to them. A photograph should be as sharp as possible, unless intentionally unsharp (blurring to suggest movement sometimes works, but often doesn't). Tonal contrast must be pleasing, to give a clean look to the picture. Use light and time of day.

What do you want the photograph to say? Some statements are pure bird messages: This goldfinch eats seeds from a thistle plant. Some

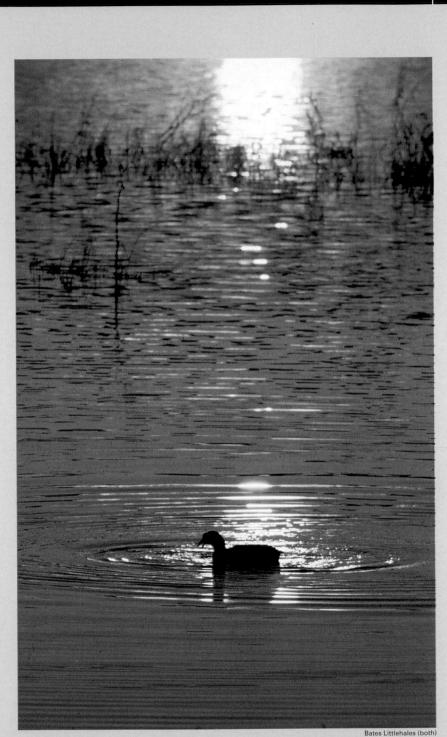

Bates Littlehales (both)

are more anthropomorphic: This hawk is fierce—you can see it in his eye. Show your message as clearly as possible. The goldfinch must be cracking the seed, not just looking at it.

Do everything you can to enhance the mood or feeling in your image. A lone gull in heavy fog creates a very different mood from a flock of gulls against a bright blue sky. I once made a photograph of a bird whose habitat was shallow water. In a drought, he was legging it across a dry, cracked plain. The mood? Heartbreaking.

Study bird lore and photo technique. Keep your statement bold and full of life—and stay open to occasional accidents that could help make your bird images great.

—BATES LITTLEHALES

A dark background sets off the Anhinga in this photograph (left), giving the image a dramatic quality. The twisted curves of both the bird and the log on which it stands are key elements in the composition.

This Wild Turkey (opposite) paused just long enough to allow a head shot—one frame only. The photographer used a close-focusing 300mm lens plus a 2x tele-extender.

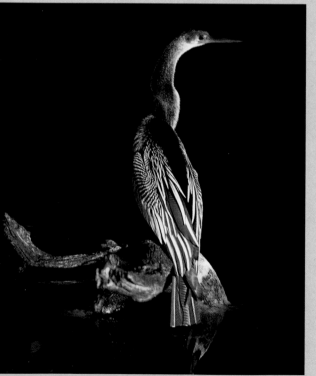

Rulon E. Simmons

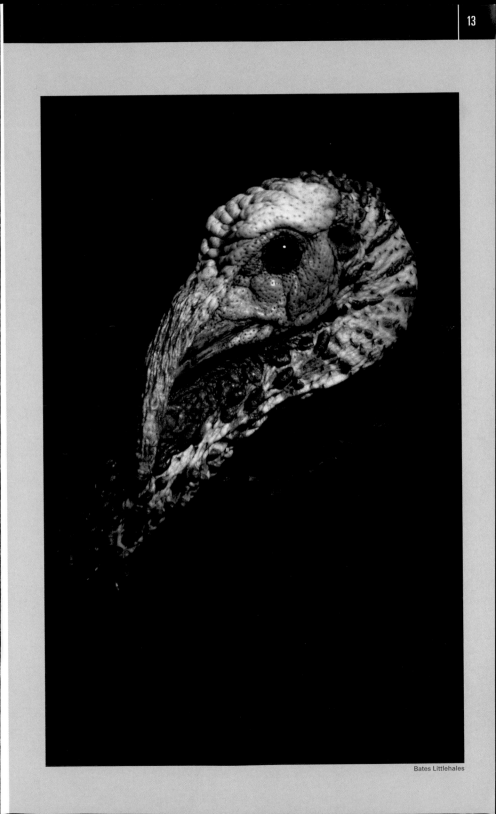

Bates Littlehales

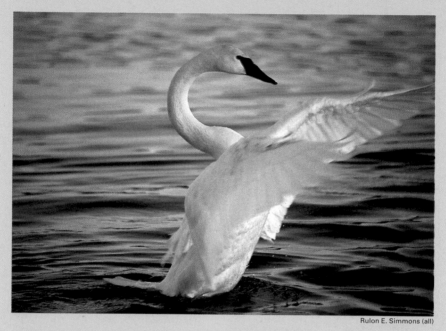

Rulon E. Simmons (all)

A little action adds great interest to this shot of a Trumpeter Swan drying off after a bath. After a dip, waterfowl predictably rise up and flap their wings, providing opportunities for action shots. Knowledge of bird behavior increases your chances of capturing great moments on film. A tight crop of a preening Northern Gannet pair (below) enhances the intimacy of the moment.

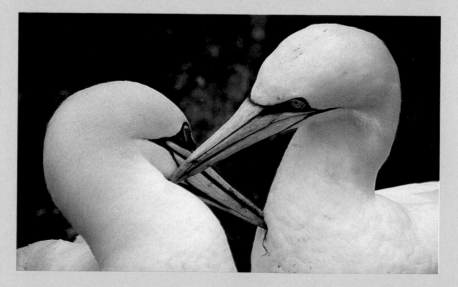

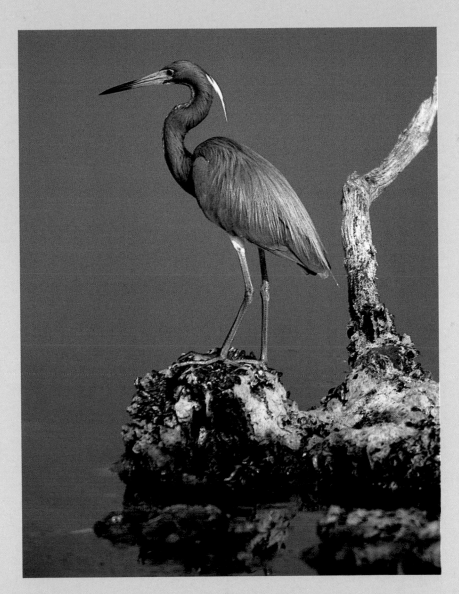

A Tricolored Heron stands out against a subtle background. The curves of the bird's perch mirror the curves of the bird's neck. The photographer used the branch on the right to frame the picture.

FOLLOWING PAGES: Bird photographs need not be close-ups to be successful. This image sets a peaceful mood by using the sweep of landscape and time of day to show a duck completely at home in its habitat.

Bates Littlehales

Camera Equipment

CLEARLY, BEFORE YOU CAN BEGIN in bird photography, you must have some equipment. What should you buy? How much equipment is really necessary? What film should you use? Let's take a look.

Today's single lens reflex (SLR), 35mm cameras have become the cameras of choice for most bird photographers. For these cameras, a wide variety of accessories is available to accommodate the bird photographer's needs. Large- and medium-format cameras and their lenses are much more expensive and very heavy to lug into the field. Cameras smaller than 35mm are generally not suitable for bird photography because they lack the long lenses necessary to get good pictures. Furthermore, the image quality is marginal at best with these small cameras. The obvious choice for most photographers will be an SLR 35mm camera. A number of good brands and models are available.

To be suitable for bird photography, the camera must be able to accommodate interchangeable lenses, allowing for the use of a long focal length lens. Beyond that main requirement, several other optional camera features should be given consideration. A built-in light meter or expertise with a hand-held meter that measures incident light can make a big difference. With either of these, precise exposures can be

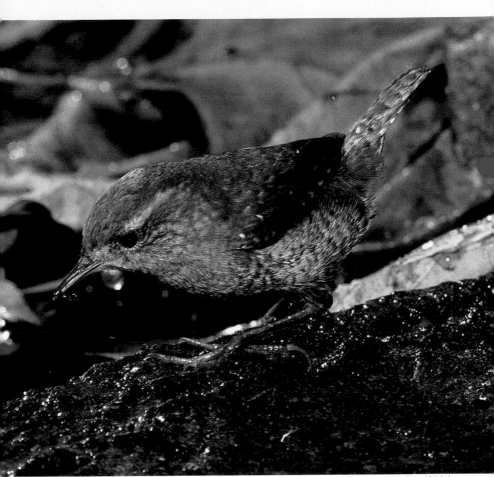

Bates Littlehales

obtained quickly under variable lighting condi-
tions. A motor drive or autowinder is a nice
accessory for nature photography. Having one
will allow you to concentrate more on the sub-
ject and let you take additional exposures in
rapid succession if necessary.

If using a consumer-grade digital camera,
make sure it has a long enough zoom lens range
to allow portraits of birds. Also, digital cameras
that offer built-in image stabilization will help
insure sharper pictures of birds.

Multiple flash made possible this image of a Winter Wren foraging on a shaded bank. The area—not the wren itself—had to be lit with flash, since the small bird was in constant motion.

Lenses

Two lenses will satisfy most situations bird photographers will encounter. Without doubt, the most useful lens for bird photography is a telephoto with a focal length of 400mm or greater. I use such a lens for at least 90 percent of my bird photography. A zoom lens in the range of 70 to 300mm works well for photographing birds that can be approached closely, as from behind a blind. Much of the bird photography that can be done without the use of a blind requires longer focal length lenses, usually in the 500 to 600mm range.

It's surprising how close you have to get to a bird to fill the frame, even with such long lenses. You can use lenses longer than 600mm, but with increasing difficulty. First, a longer lens tends to exaggerate camera vibration and subject motion. With a longer lens, there's also more physical distance between you and your subject. The atmosphere in between will often have a degrading effect on your pictures. Longer lenses are generally slower and require the use of faster films or a heavy, steady tripod.

Long telephoto lenses come in two main types: 1) refractive lenses, composed of several refracting glass lens elements, and 2) catadioptric lenses, consisting of a couple of mirror elements as well as refracting lens elements. Catadioptric lenses have the advantage of being much more compact. They can also be less expensive. Some people, however, dislike the

> **Tip**
>
> Explore the possibilities by varying your approach to any given species of bird. What will a high viewpoint convey? A head-on shot? Pretend you're shooting a photo essay, and don't get stuck on the same approach.

Three pictures of Harlequin Ducks, all equally valid, convey three different messages. Progressing from a normal focal-length lens (opposite, top) to a medium telephoto, to a 500mm lens (opposite, bottom), the photographer shows: bird in landscape, bird in its habitat, and a courting pair.

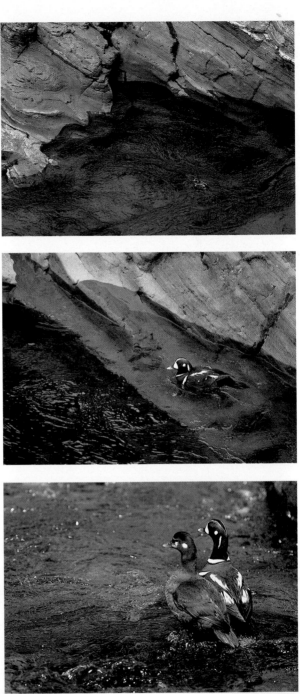

Bates Littlehales (all)

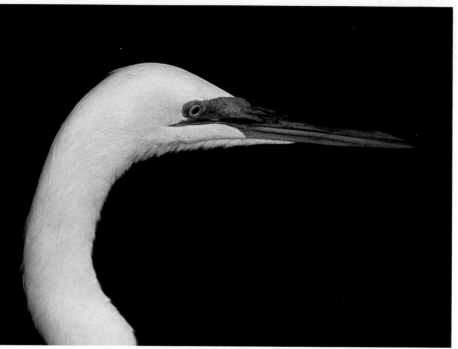

Bates Littlehales

In-camera meters have no intelligence whatsoever. They can only accurately register medium tones. The photographer metered the Great Egret and compensated for exposure in this photo. If you meter the dark background, it will wash out to medium gray. The bird will be overexposed and lose detail (opposite, top). If you meter the snow-white bird (opposite, bottom), it will turn gray.

doughnut-shaped highlights characteristic of these lenses. Another drawback is that most catadioptric lenses have a fixed aperture, which provides potentially less precise exposure control and no control over depth of field. Longer lenses suitable for bird photography must sacrifice depth of field for adequate shutter speed.

A good telephoto lens need not cost a fortune. I have had very good results with two moderately priced lenses. I started out in bird photography using a 450mm lens. Later, I

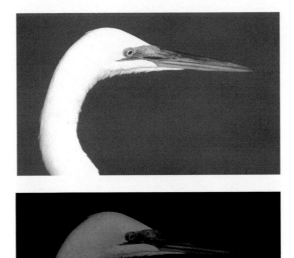

added a 70–210mm zoom lens to my inventory. As budget and circumstances have allowed, I have shifted to longer 600 and 1000mm lenses, which enable me to take pictures of birds at greater distances. Secondhand lenses are an option, too. Newer lenses with more "bells and whistles" leave some fine older lenses on the market.

Lenses purchased from third-party vendors can cost considerably less than those purchased from camera manufacturers. The optical quality of most of today's telephoto lenses is very good, though barrel construction and mechanical parts may vary in quality from one manufacturer to another.

Another significant factor in lens cost is the maximum aperture of the lens. Lenses with a larger aperture will let in more light, allowing

Tip

Buy the best lenses you can afford and be aware of their limitations. Making large, fine prints is very demanding on optics, a living room slide show less so. If you use tele-extenders, buy the ones designed for particular lenses, not "all-purpose" ones.

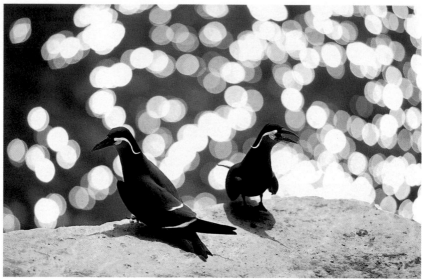

Bates Littlehales

In 1961, when these Inca Terns were photographed in Peru, catadioptric lenses were more commonly used. The relatively lightweight 500mm lens had a maximum aperture of only f/8, and did wild things to reflected light on the sea in the background.

photography under more difficult conditions of illumination and motion. But the larger the aperture, the higher the cost. If you purchase a long lens with an f-number in the range of f/5.6 to f/8, you should be able to do an adequate job with most of your bird photography. A wider aperture lens (an f/4, for instance) will cost considerably more. Whenever possible, it is a good idea to field-test a lens before buying it to make sure it will meet your expectations.

Extension Tubes and Bellows

Older telephoto lenses often will not focus close enough for close-ups of small birds such as sparrows. You can remedy this by using extension tubes or bellows, which move the near-focus distance closer to the camera.

Bellows allow for a greater range of adjustment more quickly than is possible with extension tubes. The drawback is that bellows are more delicate and clumsier to manipulate.

When using extension tubes or bellows, remember to make an appropriate exposure adjustment, if necessary. This adjustment occurs automatically when the exposure is metered through the lens, either for ambient light or through-the-lens (TTL) flash metering. TTL flash usually applies to on-camera flash equipment that uses a hot shoe.

For situations where metering through the camera is not possible, you'll have to increase the exposure to compensate for the effective increase in f/number created by the tubes or bellows. Instructions with the extension equipment should tell you how much to change the exposure for different amounts of extension.

The use of extension tubes requires exposure compensation. Experiment beforehand to determine your light loss with a favorite lens/tube combination. Fortunately, modern telephoto lenses generally focus much closer than their older counterparts and will not require extension for most applications.

There are times in the field when, even with a long-focal-length lens, you'll be too far away for good pictures. At such times, you can use a tele-converter to extend the focal length of the lens. A 1.4 converter works well and only loses one f-stop. A 2x converter will double the focal length and make the bird appear twice as close, but it costs two f-stops and could cause vignetting.

Sometimes a photographer will be able to get so close to a bird that, except for head shots or details, a longer lens is no longer suitable. Then the variable-focal-length zoom lens in the range of 70-300mm comes in handy. Unlike early zoom lenses, the quality of most of today's lenses is very good. Fortunately, the prices are also much more attractive than they used to be.

Tip

When varying from tried-and-true techniques and moving into new technical territory, work through problems at home. Don't wait until you are in the field. Keep a notebook to remember what works and what doesn't.

Exposure

Built-in light meters in most of today's 35mm cameras make getting the proper exposure quite easy. Some cameras select the exposure automatically, while others require adjustment by centering a needle or reading an LED display. You need to compensate, however, when the bird is significantly lighter or darker than its surroundings. For example, a bird against a light sky will usually come out underexposed if you're using the camera's exposure meter reading. For such cases, you'll need to increase the exposure by one or two stops to compensate for the meter reading that is unduly influenced by the lighter sky.

The Carolina Chickadee (opposite), frozen in mid-flight by high-speed flash, broke an infrared projected beam with a receiver wired to set off the camera. The ratio of good images to failures is low with this technique.

An overcast sky can be brighter than a white reflector (a white reflector having a reflectance of about 70-80 percent). This causes problems for a meter designed for a scene of around 12.5 percent reflectance. The problem is worse for a very dark bird against an overcast sky, and will require more exposure adjustment. A clear blue sky is less of a problem. If a light-colored bird is against a darker background, generally one half stop less exposure than indicated by the light meter will produce good results.

One way to get a better light reading for difficult exposure situations is to take a reading off the ground rather than the bird. A handheld incident meter can also be used to get a proper exposure reading.

Flash Photography

When circumstances call for flash photography, the flash must at least provide enough light for adequate exposure when the lens is at its widest aperture. Preferably, the flash will provide even more illumination so that the lens can be

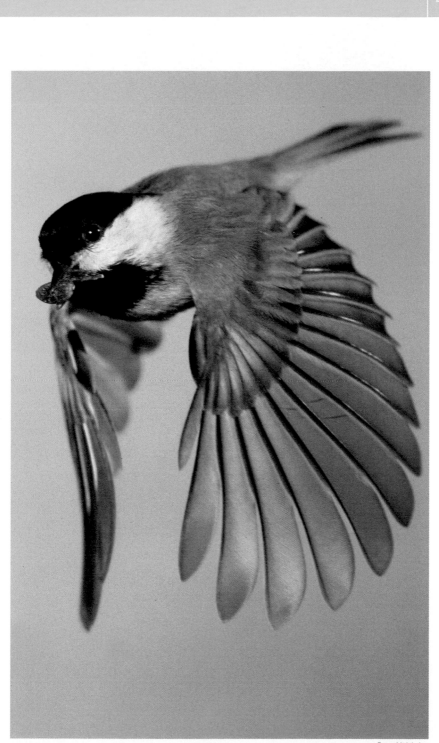

Bates Littlehales

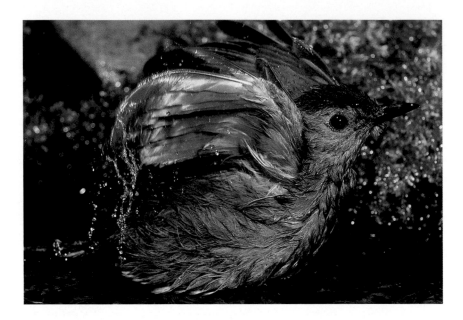

A Gray Catbird, attracted to the photographer's backyard drip pool, bathes with such rapid movements that high-speed flash was needed to capture the details.

stopped down to smaller apertures for increased depth of field. A special light-focusing lens called a Fresnel lens can be used with a flash to concentrate more light on the subject.

In flash photography, there will always be a main light. A second flash can serve as fill to lighten shadows. A third flash may be necessary to illuminate the background. All units except the one plugged into the camera will need slaves to fire them. A slave is a photoelectric device that plugs into the flash and causes it to fire when it "sees" light from another flash. Many cameras include built-in wireless triggering that works with flash units via infrared beams.

Diffused flash will be gentler than direct flash. Gauze or commercial diffusers help create softer, more natural lighting. If you use multiple flash heads, a flash meter will prove to be another important accessory. The flash meter will tell you exactly how much light your subject will receive from the combined flashes.

Bates Littlehales (both)

Other handy items you might want to consider include ballheads, quick releases, and cable releases. Ballheads attach directly under your lens mount and allow for quick changes in the lens position in any direction, but they may not be suitable for extremely large lenses. Quick releases permit fast removal of the lens from the tripod without having to unscrew the support. Cable releases, either manual or electronic, trip the shutter with a minimum of disturbance to the camera, thus reducing the possibility of vibration. The flop of the mirror in an SLR is the worst culprit, even with a release and tripod. The worst shutter speed for mirror "flop" in many cameras is 1/8 second. Tests with your own camera and lens will help you determine what it is for yours.

Image-stabilizing lenses, which facilitate handholding at slower shutter speeds, are also available. This exciting new technology helps eliminate the need for a tripod in many

Cassin's Auklet only comes ashore at night. The situation called for more punch than on-camera flash could normally deliver. A Fresnel lens in front of the flash focused the light and provided additional f-stops.

FOLLOWING PAGES: To bird-biased viewers, this is a photo of Short-billed Dowitchers feeding in a marsh. To others, it might be a landscape ornamented by birds. Whatever the point of view, the picture must work as a strong photograph to command attention.

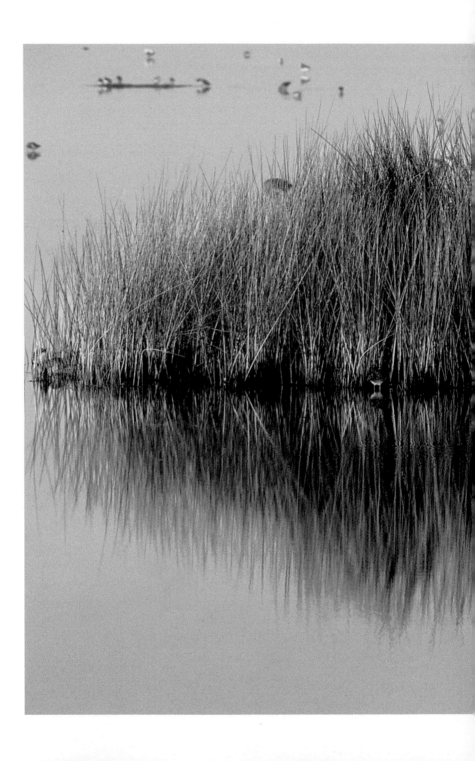

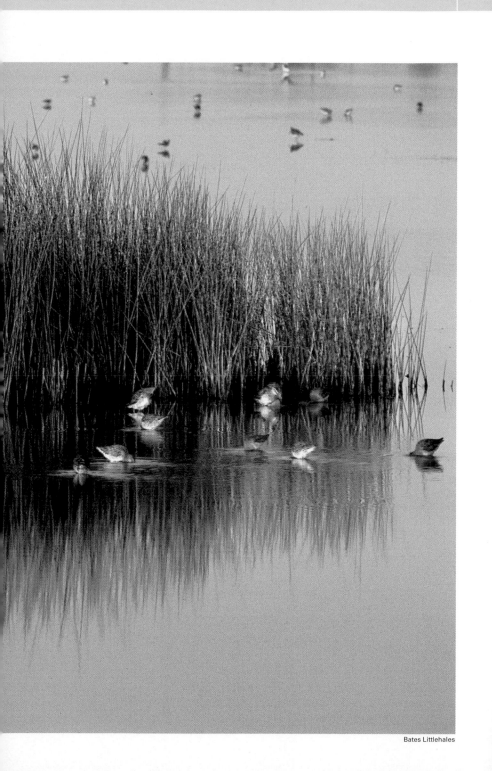

Bates Littlehales

situations. A general rule of thumb for hand-holding a lens is to use a speed at least as fast as focal length. The new technology allows the photographer to use a slower shutter speed, which in turn allows the lens to be stopped down as much as two stops.

Tripods

A sturdy tripod is an important piece of equipment for bird photographers. Use a tripod with lenses longer than about 300mm. Get a model that has sufficient height extension to enable you to photograph birds in trees from a comfortable standing position. A quick-release that screws into the lens mount allows for efficient attachment to the tripod as you set up for a shot. Better tripods offer a choice of heads, each with different mechanics.

Film

After selecting a camera and lens, you'll need to choose film. The first consideration is whether to use color slide or color negative film. Most photographers choose slide film for book or magazine reproduction and for presentations. Many also prefer the quality of slides for general nature photography (slide film will give greater tonal range between lights and darks than is possible in a print). Photographers usually choose negative film when they want prints only.

Every photographer has one or more favorite films. For many years, Kodachrome was my favorite for nature photography. Kodachrome films have very good resolving power and excellent speed/grain relationships.

More recently, I have done most of my bird photography with the newer Elite Chrome 200 film. This film gives relatively high speed with

Tip

Handholding long lenses gives more freedom to quickly relate foreground to background, but the technique requires lots of practice.

Rulon E. Simmons

To blur or not to blur? The use of a slow-speed flash produces an impression-istic image of a Common Redpoll (above), capturing the feeling of flight.
The White-breasted Nuthatch (below) was stopped by high-speed flash.

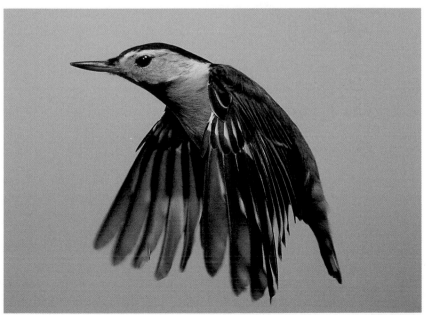

Bates Littlehales

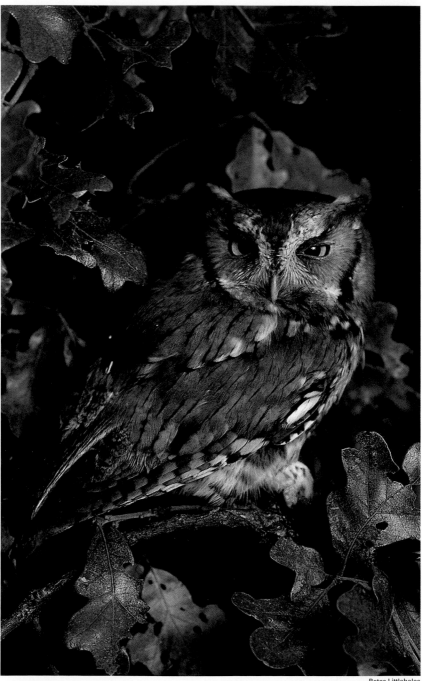

Bates Littlehales

quality previously associated with only slower films. Furthermore, it pushes very well up to three stops for use in extremely challenging conditions. For flight photographs, I usually push this film to E.I. 320. Pushed Elite Chrome 200 provides great results, maintaining excellent color balance without building up too much contrast or film grain.

An ISO 50 speed film is at the lower threshold of suitability for most bird photography. Photographers with very fast, generally expensive lenses use films in this range. But even then, they often push these films another stop to get the necessary speed to avoid blurred pictures. By using a little faster film, one can get a higher percentage of good pictures, often while using less expensive lenses. This helps in low-light conditions or when shooting birds in flight.

Since bird photographers usually work with long lenses that magnify motion of active birds and have relatively shallow depth of field, the extra speed can also be helpful even under full-sun conditions. Faster-speed films will allow you to increase the shutter speed, which helps stop motion, thereby reducing the chance that camera or subject motion will ruin the picture. Alternatively, you can decrease aperture size, which increases the depth of field.

There are many kinds of film on the market. In choosing one, consider qualities such as film speed, sharpness, film grain, and color rendition. Test different films under different conditions to become familiar with their characteristics. Select a film speed that works well with your equipment. Decide whether you prefer accurate colors or the more saturated colors provided by some of today's films. With testing and practice, you'll find a high-quality film that best meets your needs and suits your own style of photography.

A single flash, diffused by bouncing it off a white reflective surface, lit this Screech Owl. Often multiple flash is impractical, and measures must be taken to mitigate the harshness of a single light. As long as the reflective surface, used in this case as the light source, is larger than the subject, the light should be soft enough.

Tip

Printing through a computer to a photo-quality inkjet printer can give stunning results from either slides or color negatives.

On a hot day, dripping water attracts an Indigo Bunting. Better than the garden variety concrete birdbath, a natural-looking drip pool will attract more species into a wilder milieu. Test your skill as a set designer, then hang a dripping hose or water container over the pool.

Getting Close to Birds

YOU DON'T HAVE TO travel to faraway and exotic places to photograph birds. You can get started in your own backyard. The main thing is to get close to the birds. (I like a bird to cover at least one third of the width of the picture frame; others might prefer a different proportion.) You can get close to birds by luring them with food or drink. By putting up the right kinds of feeders and using the right foods, you'll probably be able to attract and photograph many different kinds of birds. A handy table at the back of this book lists the kind of feeders and foods most effective with different birds. Here are the basics you'll need to know.

Feeders

In my suburban neighborhood in Rochester, New York, I have been able to attract about 20 different kinds of birds to feeders placed about ten feet from my house. I position the feeders near windows for convenient photography from the comfort of my own home.

While the following text often refers to my experiences in upstate New York, the birds that you will attract will depend on where you live and your specific neighborhood. No matter where you live, you should be able to attract at least a few different kinds of birds using techniques described here.

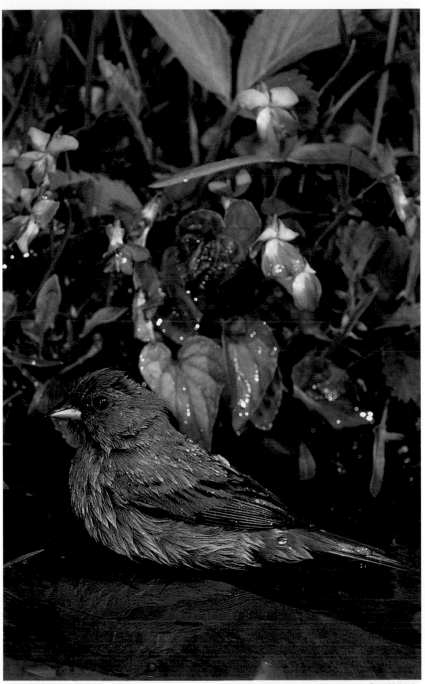

Bates Littlehales

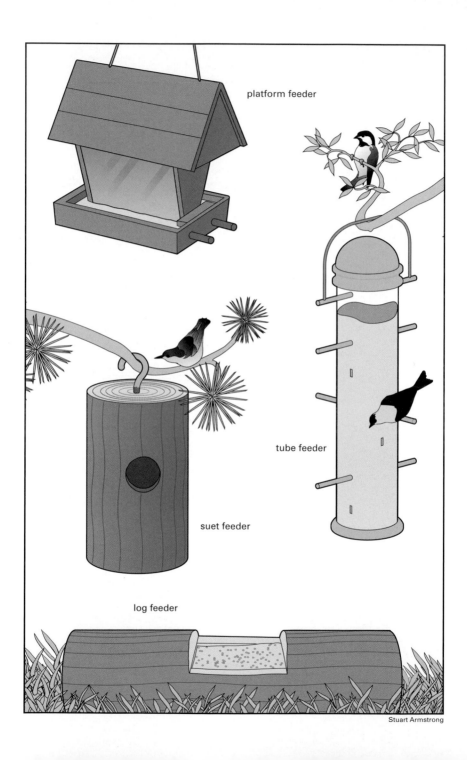

platform feeder

tube feeder

suet feeder

log feeder

Stuart Armstrong

I use four types of feeders to attract different birds. Three of these hang from fishing line strung between my house and a nearby tree. I use fishing line rather than rope to make it more difficult for squirrels to get to the feeders. Three strands of 40-pound test line does a good job. I originally used a single strand, but it broke too often. Another feeder stays on the ground. I can easily position the feeders at appropriate distances from the window, based upon the size of birds I expect to photograph.

The first of my hanging feeders is a covered platform, which I fill with a variety of seeds—cracked corn, millet, and sunflower seeds. These seeds attract a wide variety of birds in my area, including Northern Cardinals, Black-capped Chickadees, White-breasted Nuthatches, Evening Grosbeaks, Mourning Doves, Common Grackles, Brown-headed Cowbirds, House Finches, and the ubiquitous House Sparrows. Blue Jays also come to this feeder, particularly when I add whole peanuts to the menu. Observe which foods your birds prefer, and feed them accordingly. Keep in mind that prepared bird food mixes often contain seeds that birds don't particularly like.

My second hanging feeder is a tube with several small feeding holes and accompanying perches. From this feeder I dispense niger seed, which attracts such birds as American Goldfinches, House Finches, Pine Siskins, and Common Redpolls.

My third feeder is a suet feeder. I use this one only during the cooler months of the year, since suet quickly goes rancid during the hot summer months. I constructed one suet feeder by drilling a one-inch diameter hole in a log and filling it with suet. I hang the log with the hole sideways to the camera, so the suet is not visible from the

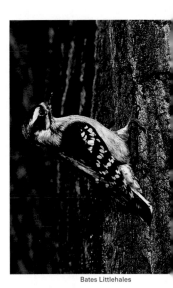

Bates Littlehales

A nearby suet feeder attracted this male Downy Woodpecker into camera range.

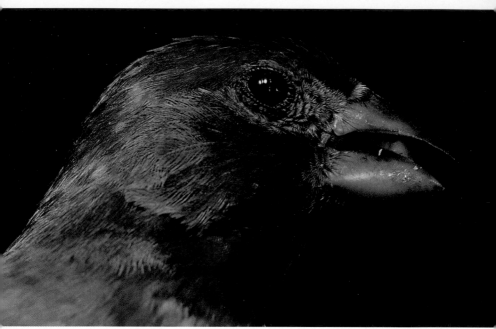

Bates Littlehales

Sunflower seeds lured this male House Finch. This species stays at the feeder longer than those that grab and go, allowing this close-up taken from a distance. The photographer used an extension tube stacked with a tele-converter.

camera position. On days when I am not taking photographs, I place a much larger quantity of suet in a wire container attached to the log. Thus, the birds get used to coming and looking for suet at the log, but I don't have to refill the feeder as often. Woodpeckers, nuthatches, and chickadees come to this feeder.

To attract Brown Creepers, I put up a second suet feeder consisting of a wire basket attached directly to a large tree in my backyard. This has successfully lured a few creepers during spring migration. In winter, it also attracts other suet-loving birds.

Finally, I occasionally set up a log feeder on the ground. I hollow out a spot in the top of the log in which to place food. Sometimes I scatter food in the grass in front of the log. I photograph birds at this ground feeder from my basement window.

The birds that come to this feeder include sparrows of various kinds, plus Dark-eyed Juncos, House Finches, Mourning Doves, and Common Grackles; although other birds such as Northern Cardinals, Pine Siskins, Blue Jays, and Black-capped Chickadees will also occasionally feed on the ground. My best picture-taking opportunities at this ground feeder occur during spring and fall migrations, which bring many temporary visitors, such as White-crowned Sparrows, White-throated Sparrows, Field Sparrows, American Tree Sparrows, Song Sparrows, Pine Siskins, and Dark-eyed Juncos. The juncos often overwinter.

Setting Up for Feeder Shots

To get the best possible picture quality, I avoid shooting through glass windows. Instead, I have made a window insert out of a board in which I have cut an opening for my lens. The opening is as small as possible in order to help keep out cold air during wintry weather. I have attached a piece of imitation leather that fits snugly against my lens.

For the ground feeder, I need a larger opening so that I can vary my distance from the birds, depending on whether they land on the log or on the ground in front of it. This allows me the flexibility to adjust the focus and image size to suit the situation. To minimize cold air coming into the house, I made a booth out of plastic sheeting to surround the window area. I also put up a piece of dark cloth so that the birds can't see me. I avoid quick movements of my lens so as not to frighten the birds.

To achieve a natural look in my photographs, without feeders or other man-made objects showing, I attach branches to the hanging

Tip

Simplifying your background should be a major consideration in all bird photography. Become aware of visual clutter. Too many distractions go unnoticed until your photographs come back from the processor.

feeders and photograph birds as they land before going to the feeders. For better-looking pictures, I remove bird droppings or other distractions from the branches. I also try to avoid showing a cut or broken end of a branch.

The ground feeder looks natural because the food slot on top is out of camera view. I usually pile some leaves or branches a few feet behind the log to serve as an out-of-focus background. The log becomes the background for birds feeding in the grass in front of it.

Depending on where you position your feeders, they will usually receive sunlight only part of the day. With flash, I'm not limited to a couple of hours when the sun is in just the right position. Also, I don't have to worry about clouds and other changeable conditions. Using flash, I can photograph from sunup to sundown.

To get the most natural look possible from my flash photography, I generally use three flash units. I set up the first one as the main light, positioning it slightly above the bird's expected location and to one side at an angle of approximately 45 degrees. The second light is a fill flash aimed at the feeder from the other side of the lens, not far from the camera axis. This flash, set at about one stop less exposure than the main light, helps lighten the shadows. The third light illuminates the background to prevent it from going completely black from underexposure. The extra flash heads are triggered by slaves when they sense light from the flash attached to the camera.

When possible, I use natural foliage as a background. When no suitable natural background is available, I hang a green, brown, or other natural-colored blanket or cloth to serve as an out-of-focus background.

For photography at my feeders, I often use a

450mm lens with extension tubes, the tubes being required for closer focusing than my lens normally allows. Be aware that long-focal-length lenses focused at a close distance have very shallow depth of field (about an inch at the widest aperture of a 450mm f/6.5 lens). This makes careful focusing imperative.

It is easier to obtain sharp focus across the whole bird when its body lies in a plane perpendicular to your line of sight (a side view). If the pose is something other than this, a smaller aperture may be needed to get the whole bird in focus. To compensate for the smaller aperture, you must use a slower shutter speed that, depending on the film speed, may be too slow to freeze the bird's movement. If the whole bird cannot be brought into focus under the existing circumstances, you should at least make sure that the eyes are in sharp focus.

In taking pictures of birds at feeders, I prefocus my camera on the branch where I expect the bird to land. I usually have to follow up with a last-second adjustment to the focus, depending

In this setup for photography at feeders, (below), a main flash is triggered by a slave. A sync cord attached directly to the camera fires the fill flash, set farther back. A third flash (not shown) illuminates the area behind the bird. The photographer positions the camera lens through a hole in a board placed in an open window and takes pictures of birds as they land on a branch near the feeder.

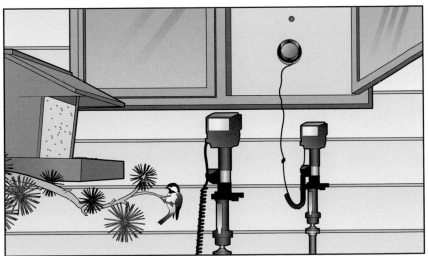

Stuart Armstrong

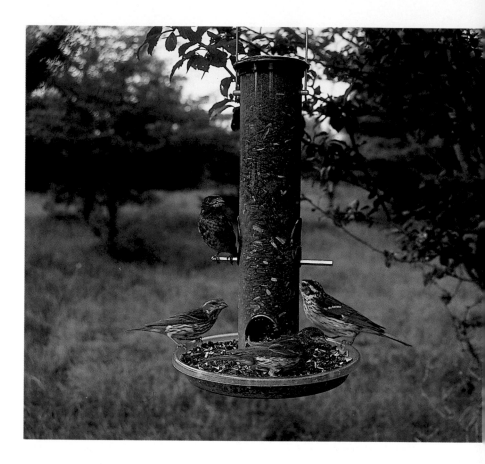

A West Virginia feeder brings in Purple Finches and a female Rose-breasted Grosbeak. The photographer used a remote tripper and a wide-angle lens to give a sense of the surroundings.

on the exact position of the bird. Fast action is necessary because the bird usually lands only momentarily on the branch.

If you have several feeders, you'll probably have to choose just one each time you set up your flash units for photography. This can be frustrating when an interesting bird comes to a feeder that has not been prepared for photography. But that's all part of the game. Sometimes a quick change of setup will allow you to get the picture you want, and sometimes it will just add to the frustration as different birds alternate visits at the various feeders. Fortunately, most birds

Bates Littlehales

will make repeated visits to your feeders.

From time to time, my friends tell me about interesting birds that have shown up at their feeders. I have taken my lighting equipment to their homes and set it up in a similar fashion. I can also take a portable blind to set up about eight to ten feet from the feeder. With this arrangement, I can photograph birds just about anywhere. I have also set up portable bird feeders when I have been traveling. Sometimes I use a small dome tent as an easy-to-assemble blind from which to photograph birds on the ground.

If you have never used a bird feeder before, you will probably be amazed at the variety of birds it will attract. Shortly after setting up my first feeder, I began seeing bird species in my yard that I'd never seen before. To keep my bird clientele coming back regularly, I make sure to keep my feeders supplied with food.

You don't necessarily have to have a bird feeder in order to attract birds with food. Some birds, such as jays, will take food scraps at picnic areas. In public parks, sometimes wild ducks or other birds look for handouts such as bread and corn. In the winter, when food is scarce, I have fed sunflower seeds to Black-capped Chickadees right from my hand. Make sure to obey local ordinances regarding feeding of animals.

Winter Photography at Feeders

When winter snows fly, don't put your camera away. You can take lovely pictures of birds such as cardinals, juncos, and chickadees at your feeders in winter.

Think about the kind of scene you want to create. There are lots of possibilities. You can add a cut pine bough to the scene; it will stay fresh-looking for several days in cold weather. Add

Backyard portraiture: Mourning Dove. Add an extension tube of moderate length to a camera body. Attach a 1.4 tele-extender, then a 300mm lens. Rig your flash setup close enough to the bird's perch on the feeder to stop down to f/16. Sit comfortably in your blind, focus, and shoot. With practice, it's a piece of cake.

pine cones, ice, and snow and you have the makings of an artistic masterpiece. After the holidays, you can get all the branches you want from discarded trees. At other times, you should have little difficulty finding a tree from which to trim a small branch.

Berry branches can provide another artistic effect. It's a little harder to get snow to stick to these branches than to conifers; one method that works is to spray water on the branch and berries while sprinkling snow over the top. You can place little chunks of snow and ice between the berry stems as well.

Here's one more feeder photography trick. Some birds, chickadees in particular, zip into the feeder and leave so quickly that it is difficult to get good pictures. I have lots of frames of empty branches to prove it!

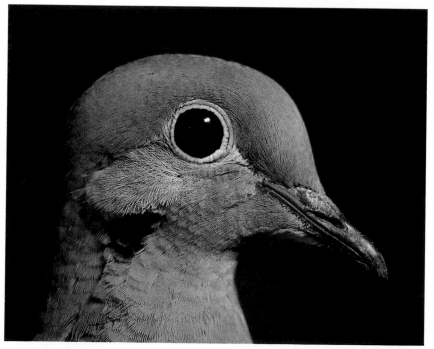

Bates Littlehales

In a moment of inspiration, I attached a mirror to the feeder. It had the desired result—at least temporarily. When the startled birds first encountered the reflection, they stayed on the branch just long enough for me to get some pictures. It didn't take the chickadees long, however, to figure out that my mirror was no threat. They soon went back to their old ways.

Recorded Bird Calls and Other Sounds

Some birds are territorial and will drive intruders away, particularly others of their own species. You can draw some of these birds into close range by playing recordings of their songs. The male bird, thinking an intruder has entered his territory, will come out to defend the territory. This technique usually works well only during the nesting season. Use it sparingly so you don't adversely affect the nesting of the birds.

Tip

Be aware that on some public lands, the use of tape recorders to lure birds is discouraged or even illegal. Check with the people in charge.

The first time I tried the tape-recording trick, I was amazed at how well it worked. My son, Michael, and I were at a nearby pond. We pulled our van off the road and parked by some cattails. No birds were in sight. I had Michael play the Red-winged Blackbird tape. Immediately, seemingly out of nowhere, a Red-winged Blackbird appeared close to the van.

I have often been able to lure Red-winged Blackbirds to within eight to ten feet of my van—close enough to get full-frame shots using a 450mm lens. I've had a similar experience with a Song Sparrow. You'll find a list of other birds that should respond to bird calls and songs in the back of this book.

Great Horned Owls can be lured into close range with either an actual recording of the bird's call or with a good human imitation of it. Barred and Northern Saw-whet Owls, as well as

The first days of spring, before trees have fully leafed out, are ideal for colorful, unobstructed shots, like this one of a Blue Jay approaching a backyard feeder.

FOLLOWING PAGES: Scarlet Tanagers cannot be coaxed to a feeder, but they will often come to water. Learn the ways of the birds you want to photograph, and you'll increase your chances of capturing birds on film.

Screech-Owls, also respond to recordings. They are best called at night, so you'll need flash, a helper to shine a light, and possibly a ladder.

Playing calls of enemy or prey species also helps to attract birds, which come to drive the perceived enemy away. A Screech-Owl call works particularly well—you never know what species of birds you might attract.

There are a number of excellent sources for bird songs recorded on CD and tape. Peterson Field Guides and Stokes Field Guide offer collections of bird songs of Eastern and Western regions of North America. Check your local library for recordings. Catalogs for birding enthusiasts should be a good source, as well.

The best way to use recordings is to copy the ones you want onto your own tape or CD. You can make several repeated recordings sequentially on the tape. About five minutes worth of recording for a given bird species should be sufficient.

Squeaking and "Spishing"

Many songbirds also respond to "squeaking" and "spishing" sounds. You can make a squeaking noise by sucking on the back of your hand. The resulting noise sounds like a bird in distress, and can be effective in bringing birds into close range. This technique can be successful in drawing small birds, which are often hiding in bushes, out into the open where they can be photographed.

Making a sound like "spisssh, spisssh, spisssh" (called "spishing") also works. Gray Catbirds respond particularly well to these sounds. Other birds that can be lured closer with squeaking and spishing include: Blue Jays, Red-eyed Vireos, Song Sparrows, White-throated Sparrows,

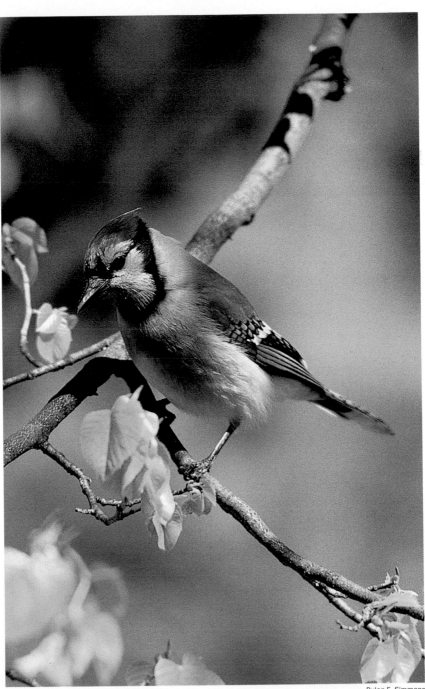

Rulon E. Simmons

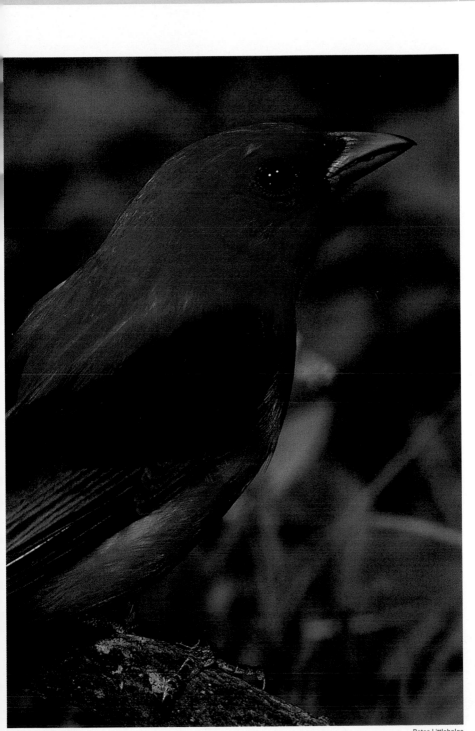

Bates Littlehales

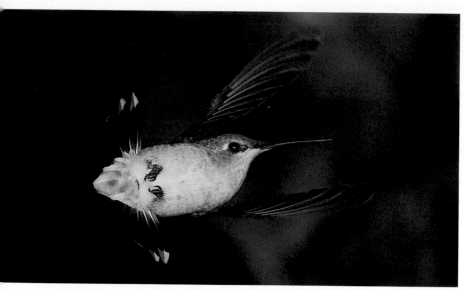

Rulon E. Simmons

Hummingbirds move so fast that it's impossible to know how a picture of them will turn out. Two flash heads set at reduced power to shorten flash duration froze the aerial acrobatics of this Broad-tailed Hummingbird (above). Natural light can't allow a shutter speed fast enough to stop wing action, but the blur of this Ruby-Throated Hummingbird's wings doesn't harm this picture (below).

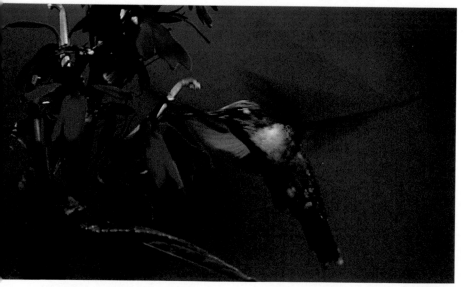

Bates Littlehales

Brown Thrashers, Scarlet Tanagers, White-breasted Nuthatches, Blue-gray Gnatcatchers, kinglets, towhees, chickadees, and titmice.

Hummingbirds

Hummingbirds are attracted to specialized feeders that dispense sugar water through a tube. One part sugar to three parts water makes a good mix.

To get a natural look, I place trumpet-creeper or some other favorite flowers of hummingbirds inside or in front of the feeder opening. When a blossom begins to wilt, I replace it with a fresh one, which I sometimes keep in water or a nearby refrigerator. I crop the picture so the feeder does not show. In some western areas of the United States, thistle flowers are plentiful and easy to use in hummingbird photography. For feeders with multiple openings, I put tape over all but one tube, forcing the birds to come just where I want them.

Hummingbirds will habitually return to the same perch time after time. By focusing a long telephoto lens on an observed resting spot and waiting for the bird to return, you can often get good pictures. If you find a bird already sitting on a branch, you may be able to get close to it by moving in very slowly.

Flight Photographs

Getting good pictures of hummingbirds in flight is a challenge. Try to photograph them as they hover near the feeder. You will find that you'll probably have a higher failure rate with pictures of hummingbirds than with most other birds. Don't be discouraged— the good shots you get will be very rewarding.

Flash can be a great help in photographing hummingbirds in flight. The flash will help stop

Tip

Make sure you clean hummingbird feeders and replace nectar often, especially in hot weather. Direct sunlight causes food to spoil more quickly, encouraging a deadly mold.

the motion of the wings, which move at a rate of about 50 beats per second. Fixed-intensity flash equipment, having a flash duration of around 1/1000th of a second, will not totally freeze the motion of a hummingbird's wings. Nevertheless, you can take some very nice pictures showing a little wing movement with such flash equipment, or even sunlight. These pictures will be quite effective as long as the body of the hummingbird looks sharp.

Some flashes have provision for cutting the power down by factors of two (1/2, 1/4, 1/8, 1/16, 1/32 power, et cetera). The reduction in power is achieved by a corresponding decrease in flash duration. Using the lowest fractional power practical within the limits of the f-number of the lens and the required depth of field will allow you to reduce or even eliminate the motion of the hummingbird's wings in your photographs.

A word of caution regarding metering exposure for reduced power: Flash meters will often give incorrect readings for fractional power settings because the flash duration is often too short to activate the meter's measuring circuit.

To get around this problem, meter your flash on full power. Then open up one additional stop for each time the power of the flash is cut in half. Also apply any adjustment necessary if you use extension tubes.

I have found that a 70-300mm zoom lens works quite well, since most hummingbirds will allow a relatively close approach. Such zoom lenses usually have fairly wide apertures and can be quickly adjusted for different-size hummingbirds. Some serious hummingbird photographers build or purchase special flash equipment that gives them flash durations as short as 1/50,000.

Tip

If you travel to a location that caters to hummingbird photographers, consider bringing your own feeders for use in a nearby campground, away from the crowd.

This sequence demonstrates a method devised by author Rulon Simmons for making backgrounds. First, choose a negative from a photograph that has a background you like. Next, make a 16X20-inch print of part of the image, out of focus and to the desired hue. The author used this leafy background for a Black-chinned Hummingbird (below).

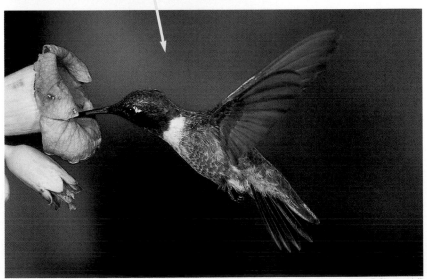

Rulon E. Simmons (all)

Bates Littlehales

A branch placed to minimize background clutter provides a stopping place for this Dark-eyed Junco and focus spot for the photographer.

Experiment with Backgrounds

Pay attention to the background for your hummingbird photography. If the background is sunlit, you may get "ghosting" around the edges of the bird in your photographs. This occurs because the shutter is open longer than the duration of the flash, causing a secondary image made by ambient light.

Some photographers hang blue paper behind the bird, making a background that looks like sky. If you use paper, take special care to make sure that it is evenly lit so no shadows from the bird are cast on it. Often, the perfect uniformity of the blue paper looks artificial. I prefer using foliage as a background. Sometimes I use a mottled green background that simulates foliage.

Artificial backgrounds are particularly noticeable when each picture in a set was taken with the same background. I've often noticed that some of the best hummingbird photographers use the same old backgrounds time after time. In a group of pictures, you will sometimes see all sorts of hummingbirds feeding on different flowers, all with the same background. The background would be wonderful for any individual picture, but seen time and time again in different contexts, it can be annoying to the careful observer.

I found myself in the same trap with my pictures. With just two painted backgrounds, my images were beginning to look an awful lot alike. I painted new backgrounds, but they were nothing great. I could have used plain-colored paper, but I wanted something less artificial looking.

Then one day an idea hit me. Why not just photograph a background and use a large print as part of my photographic setup? My first thought was to go out and photograph out-of-focus vegetation. (An out-of-focus background will usually compete less for attention than one that is sharply focused.) Then I realized that I didn't even have to shoot additional pictures; I could simply print a portion of sky or vegetation from any number of my existing photographs. The detail doesn't really matter, since just about anything that is printed enough out of focus, particularly if it is a natural-looking color, can work well.

I had been using 16x20-inch painted backgrounds, so switching to photographic backgrounds of that standard size was natural. Precise color balancing is not critical. You can use the same negative to make a variety of different backgrounds by choosing different sections, different magnifications, and/or different

Tip

When hummingbird nectar comes into contact with feathers, it's destructive. Use a spray water bottle to clean off spilled nectar after filling and rehanging the feeder.

degrees of focus. You can also vary the color balance and density of the prints to suit your own taste. For example, I have printed fall leaves to a greener color balance than was in the original photograph.

A Rose-breasted Grosbeak suddenly appears in camera range and frames itself in the viewfinder. Click. You made the photographer's day, Grosbeak!

I usually place the background two or three feet behind the bird, approximately the same distance from the bird as the flash units are from the bird on the opposite side. The flashes that illuminate the hummingbirds also light the background. By placing the lights slightly above the birds, shadows fall unseen below the background. Since the background is farther away than the birds, it gets less illumination.

If the background is made at normal density, it will show up slightly darker when photographed with the bird. This usually works fine. If you want a lighter background, it can be printed lighter. Printing on matte paper helps prevent unwanted reflections.

The backgrounds can be mounted on cardboard, with paper clips placed through holes in the corners for hanging. I hang the backgrounds from an aluminum frame.

A few additional tricks can add variety to your hummingbird backgrounds. If you plan to use a particular flower in the foreground, try photographing a complementary background ahead of time, incorporating some of the same type of flowers. If you want a simulated sky background, start with a photograph of sky that incorporates some tonal variation so that it doesn't look like just a sheet of blue paper. You can also take a neutral area of any picture and print it extra blue.

Tip

Unless you know precisely how your subject will absorb or reflect light, you should bracket exposures to be safe. Some feathers reflect more light; others absorb it.

With a little creative work in the darkroom, you can make almost any photograph into a suitable hummingbird background. Give it a try with negatives of your own!

Bates Littlehales

Rulon E. Simmons

Birdbaths

Many birds that won't come to a feeder will come to a birdbath. In areas of the western United States where there is still a lot of wild habitat with plenty of natural food, water is often more popular than food for attracting birds. Generally, the drier the surrounding area, the more effective your birdbath will be.

In the eastern United States, where water is plentiful and many natural areas have been replaced with building tracts, bird feeders may be the most effective way to attract birds. But birdbaths still offer lots of opportunities. During migration, a drip pool is a powerful magnet, no matter how wet the climate.

Birds readily come to the sound of dripping water. You can create a drip pool by suspending

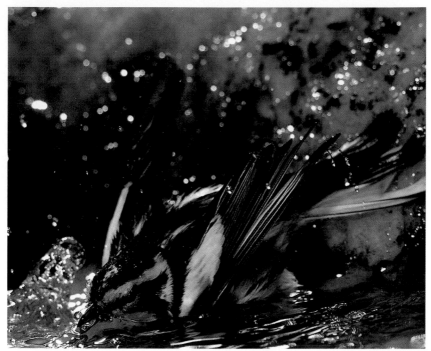

Bates Littlehales

A Rufous-sided Towhee (opposite) fluffing its feathers in a gentle bath, was photographed in natural light. In contrast, the hearty splashing of a Blackburnian Warbler (above) was captured with electronic high-speed flash.

a garden hose over a birdbath, or make your own device using a plastic soft-drink bottle. Fill it with water, tie a string around the neck, and hang it from a branch over the birdbath. Poke a hole in the bottom of the bottle with a small nail, and adjust the cap to control the drip rate.

In winter, birds can have a hard time finding water. You can put out hot water from time to time, or use a birdbath that heats the water enough to keep it from freezing. For natural-looking photos, place a branch near the birdbath and photograph the birds as they land on it.

Setting up a Natural-looking Pose

The rules of good composition apply to bird photography. Pay attention to the background for your subject. Try for a background that is not cluttered with distractions. I make a special effort to get a natural look in my photography, eliminating manmade objects such as utility poles, wires, fences, and buildings.

Clutter competes with the subject for attention. Even natural elements, such as a bright and out-of-focus branch, or one that blends into the bird's outline, can be distracting. Try controlling the background by waiting for the bird to move, shifting your position, or luring the bird with food or water to another location.

Working with a long lens often results in shallow depth of field. In the absence of bright, distracting elements, this can help blend the background into a pleasant blur of color.

With the background under control, work with the bird itself. Your job is easy if the bird is at rest. Feeding birds, which are usually in near-constant motion, provide an additional challenge. If your shutter speed won't stop the motion, try making a squeaking sound. This will often cause the bird to stop and stand alert.

Always keep the bird's eye in sharp focus—it's what people usually notice first in a photograph. As the bird moves its head, take your picture when you see a reflection, called the catchlight, in its eye.

Tip

Continually focus on the bird's eyes—often the rest will take care of itself. If the eyes are not sharp, you'll be disappointed in your photograph.

Niger seed lured these American Goldfinches to a backyard feeder. Once the birds came to the feeder on a regular basis, the photographer placed a thistle flower next to the feeder. A few niger seeds sprinkled on the thistle blossoms made the perch an instant hit with the goldfinches, providing an excellent natural-looking scene for photographs.

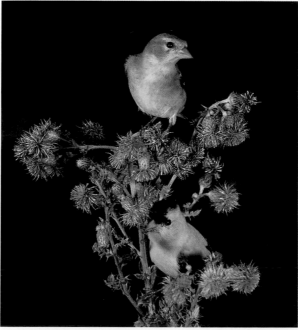

Rulon E. Simmons (both)

In Pursuit of Birds

WITH SOME CARE AND PATIENCE, you can stalk quite a number of birds successfully with a camera. Some species, of course, are more approachable than others. Birds of a species found in one locality may be more approachable than birds of the same species in a different place.

Birds on public beaches, in parks, refuges, and other areas where they are used to seeing people will often be more habituated and more approachable than similar birds in other locations. Zoos with outdoor exhibits often attract a variety of wild birds that can be photographed quite easily. For example, I once photographed a very tame Northern Mockingbird at the National Zoo in Washington, D.C., using only a 70-210mm zoom lens.

Obviously, the tamer the bird, the easier it will be to stalk. Some birds known for their tameness include: Gray Catbirds, Spruce Grouse, Gray Jays, Saw-whet Owls, White-tailed Ptarmigan, Least Sandpipers, Black-capped Chickadees, Pine Grosbeaks, kinglets, and dowitchers.

Ways to Approach Wary Birds

There are ways to bring home good pictures of wary birds, too, if you follow some basic guidelines. First, take your time when you approach a bird. Move slowly, pretending not to be too interested in the bird.

Take an indirect path toward the bird. Do not

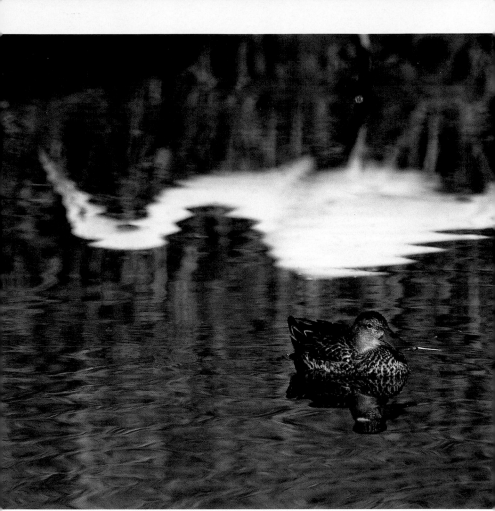

Bates Littlehales

stare—it could be seen as threatening. Look in another direction as much as possible, with only occasional glances toward the bird.

Move toward the bird a short distance at a time, stopping now and then to let it become accustomed to your presence. It will help if you move when the bird is looking away from you. Crouching down can help because it minimizes your profile. This usually makes you appear less threatening.

Hunkered down on the bank of a wetland area, the photographer caught the reflection of a Great Egret behind a female Northern Shoveller. Stalking gives you leeway to move the camera and better relate foreground to background.

The photographer used
a 600mm lens to cap-
ture this intimate por-
trait of a Spectacled
Eider in a captive
waterfowl collection.

Shoulder Stocks

Wherever practical in bird photography, I use a
tripod, which can hold the camera and a long
lens rock steady in the field. But shoulder stock
mounts developed for cameras work well for
stalking birds.

A shoulder stock will come in very handy for
photographing birds in flight with a long lens.
Be sure to use film that is fast enough to mini-
mize any blurring of the image that might occur
due to camera movement.

Brace the shoulder stock against a tree or
some other firm object to reduce motion. If no
such object is handy, shooting from a kneeling
position helps. If you have a shoulder strap you
can tighten with pressure from your arm; this
will also help reduce movement of the lens. An
image-stabilizing lens, if you can afford one, also
makes stalking easier, eliminating the need for
tripods or shoulder stocks in many situations.

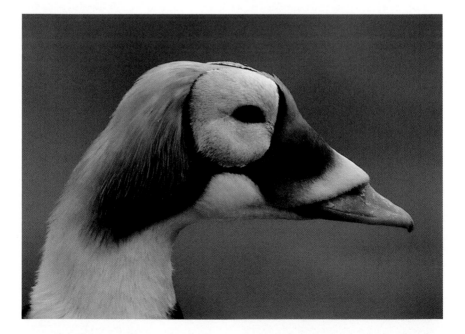

Lighting Conditions

Before going stalking, think about where the sun will be relative to you and your subjects. For example, if you are photographing birds along the west shore of a north-south running shoreline, you will want to photograph in the afternoon rather than the morning to get good front-lighted subjects.

Full sun can help bring out the brilliant colors of a bird and provide good contrast in the ratio of lights to darks in a picture. Hazy sunlight, or even the flat lighting of a cloudy day, may occasionally be desirable for white birds such as gulls.

White birds usually contrast sufficiently with their surroundings, even under overcast conditions. But in full sunlight, there is often too much contrast between the white feathers and dark feathers or other dark areas of the picture.

A boat did the stalking of this pair of Whooping Cranes while the photographer handheld a 600mm lens comfortably on deck. A tripod would have conducted engine vibrations to the camera.

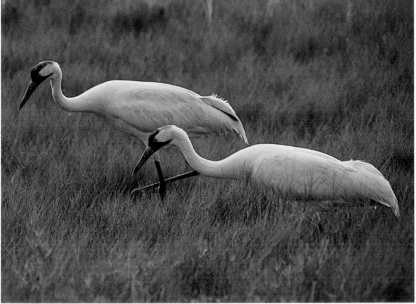

Bates Littlehales (both)

In these cases, the whites will either look washed out or the dark areas will lack detail, depending on how you set the overall exposure.

Shorebirds

Many shorebirds lend themselves to stalking, particularly if they are along a shoreline rather than in a large open field or mudflat. These birds are often quite intent on feeding, so if you approach cautiously, you should be able to get close to them.

While shorebirds are feeding, they are typically in constant motion, probing in the mud or sand for food. Don't pass up the opportunity to get some behavioral shots of the birds feeding in their habitat. The action can make for interesting pictures.

Getting a Bird's Attention

If you have difficulty getting a bird to hold still for a picture, making a quick noise will usually cause it to stop and stand alert, at least momentarily. If you make the same sound too many times, the bird will learn to ignore it. When this happens, try making a different noise. If your camera has a motor drive, the sound of film advancing after the first shot will often elicit an alert expression from the bird.

If a bird has become accustomed to your being nearby, sometimes making a quick movement with your hand will cause it to pause. If you try this with a bird before it is comfortable with your presence, though, there is a good chance that it will fly away before you have a chance to take photographs.

Fortunately, when a shorebird flies, it often doesn't go very far. You may be able to follow along the water's edge and try again in a few minutes. When shorebirds haven't flown too far

Bates Littlehales (both)

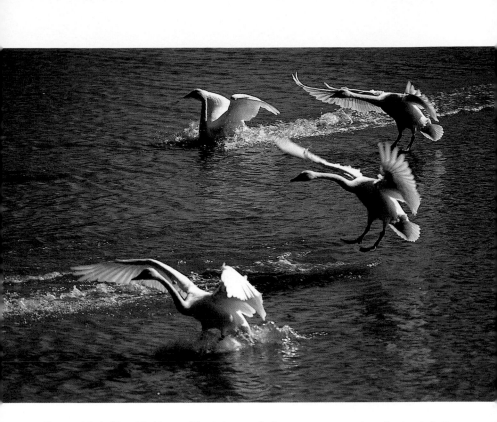

Desert birds like this House Finch (opposite) seem tamer and easier to stalk than birds in other locations, perhaps because so few humans and pets visit this inhospitable place. Tundra Swans (above) landed in an inlet as the photographer sat quietly on the bank, not even attempting concealment. Backlighting, as in these two photos, demands careful metering for proper exposure.

away, waiting for them to come closer to you will often pay off.

Sometimes you will be able to approach a bird undetected by hiding behind an object such as a dirt bank, a shrub, or tall grass. It's usually difficult to get close enough to make good pictures without being seen at all. Move slowly and quietly so that if the bird does see you, you won't appear to be threatening.

A trick that sometimes works with flocks of birds, such as gulls, is to "herd" them. To

Rulon E. Simmons

accomplish this, position yourself as close to the birds as they will allow. Wait a few minutes to let them become accustomed to your presence. Then have a helper come slowly toward you from the other side of the flock. The birds will generally move away from your helper and nearer to you. When they do, be ready.

When you're stalking birds on public beaches, there is always the chance that other people will come along and frighten the birds away. To help avoid such problems, go to the beach early in the day, before many people have arrived. It also can be helpful to have someone with you who can steer other people away from the area where you are making photographs.

Of course, when you're photographing along the shore, it's possible to have too much of a good thing: Getting a group of birds in good overall focus means dealing with a depth of field problem that can present quite a challenge. Sometimes it will be best to just focus in on one or two birds at a time.

FOLLOWING PAGES: Sanderlings feed on a winter beach at sunrise. In this case, the challenge was leaving a cozy bed in the cold and dark to arrive in time for dawn.

Besides beaches, other good places to photograph shorebirds are along breakwaters, brackish ponds, and inlets. Each of these locations will give you excellent opportunities to explore the world of birds.

Shorebirds, absorbed with hunting for bits of food, lend themselves to stalking.
The trick is to convey their characteristic motion in a still photograph.
Above, from left to right: Willet, Black-bellied Plover, Lesser Yellowlegs, and
Long-billed Dowitchers (below).

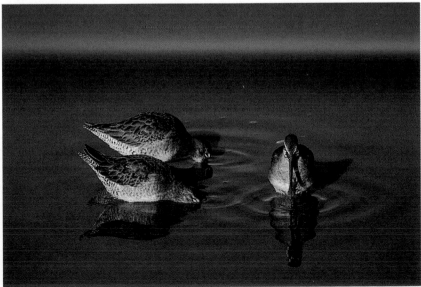

Bates Littlehales (above and opposite)

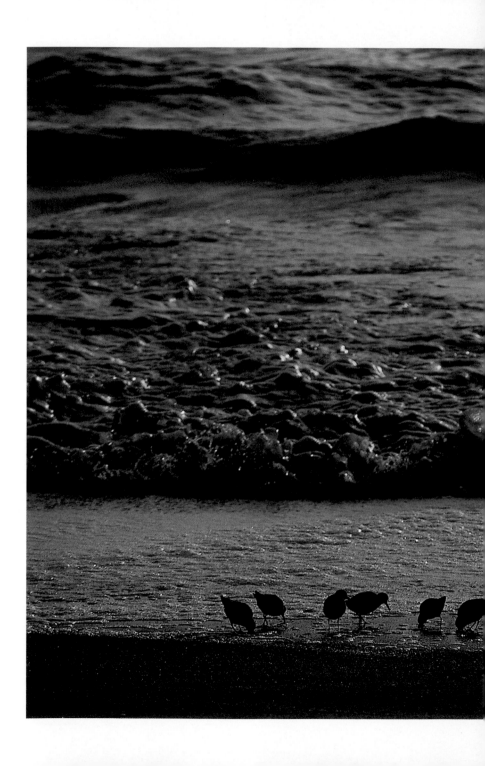

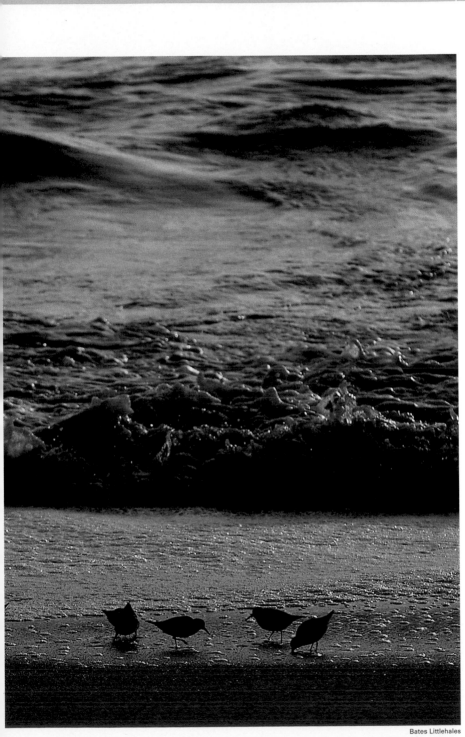

Bates Littlehales

Diving Birds

For taking photographs of diving birds such as grebes, loons, and some ducks, the following technique often works well. Stand still while the bird is on the surface. When the bird dives, run quickly to the point on the shore nearest to where you expect the bird to surface. By watching its diving and surfacing pattern, you can usually get a pretty good idea of the direction in which it will swim and about how far.

When the diving bird surfaces, make sure you are still and ready to shoot. The bird will usually accept your presence—provided you don't make any rapid movements. It's often easier to stalk diving birds when they are swimming in relatively narrow bodies of water, such as channels or streams.

Songbirds

Stalking songbirds is generally easier in the spring before the trees and bushes are fully leafed out. Fortunately, this is also the time when birds migrate through to their breeding grounds and are decked out in their finest plumages. Birds are also singing at this time, making them particularly easy to find. Learn to recognize their songs, and you'll know what birds are in the area before you can see them.

Songbirds like to sing from high vantage points such as the tops of trees or bushes. Take note of the locations that birds use for singing, and position yourself near one. Then wait quietly for the bird to return.

When birds are feeding on naturally occurring fruits, berries, and seeds, they will often ignore your presence if you approach slowly and work quietly.

A Barrow's Goldeneye takes the plunge. The split-second timing demands a sports-photography approach, familiarity with bird behavior, and, of course, luck.

The Grasshopper Sparrow (opposite) returned to this singing perch after making his territorial rounds. A 600mm lens allowed the photographer to shoot from just outside the sparrow's flight distance—the amount of space the bird needed to feel secure.

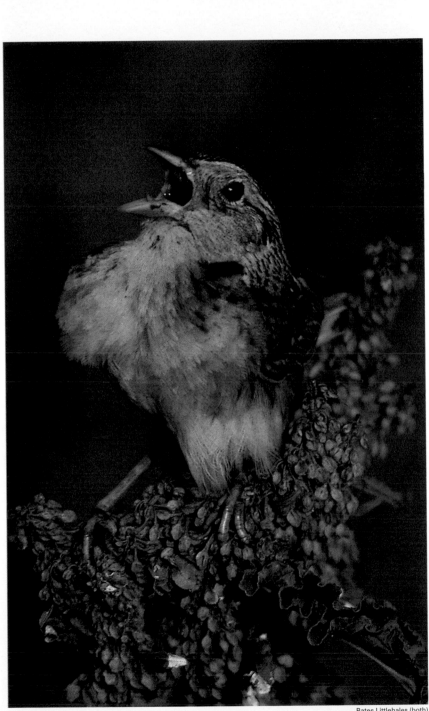

Bates Littlehales (both)

Courtship

COURTSHIP, WHICH OFTEN BEGINS before or during migration and continues into nesting, gives the photographer an opportunity to make some of the most interesting images in the bird year.

The length birds go to in order to say "look at me" and "this territory is mine" is amazing. Not all songbirds sing before reaching the nesting grounds, but enough of them do to fill the leafing trees with sound—almost as if they are warming up for the really serious singing ahead.

When the males arrive at their final destination, they use song to warn away other males and to attract females. Often they will return to the same series of singing perches—good places

In pursuit of the perfect mate: A Greater Prairie Chicken (below) struts and booms early in the morning on a traditional courting ground. Inflated throat sacs make a center of interest in the photo. A male Red-winged Blackbird (opposite) proclaims his territory with croaky song and a flamboyant song spread.

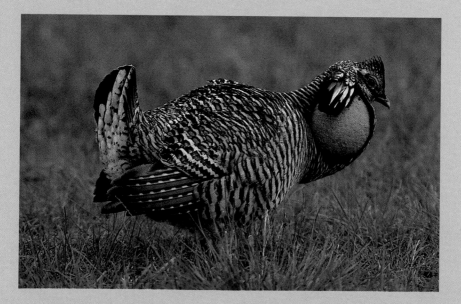

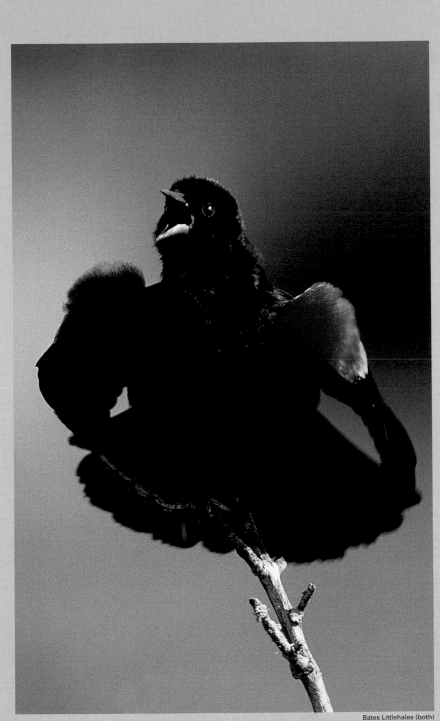

Bates Littlehales (both)

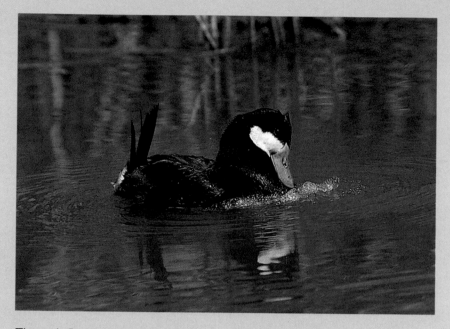

The male Ruddy Duck slaps his bill against his breast, bubbling the water in front of him in his courtship display. More difficult to capture on film was his surprising rush across the water (below) to impress the female.

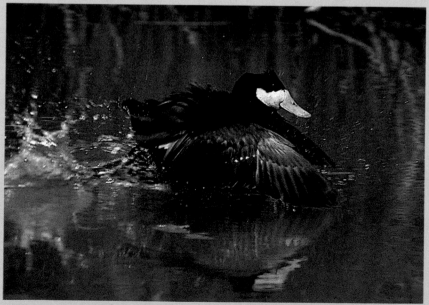

Bates Littlehales (all)

to set up portable photo blinds or do some quiet stalking. Bursts of song not only animate the birds, but are often accompanied by behavioral display antics that impress photographers as well as other birds.

The plumage of male songbirds is often the finest feathery color for courtship. The Scarlet Tanager, for instance, changes from dull winter yellow to brilliant red and wows the female, still feathered in yellow-green. In some birds, unfeathered skin parts can also change color. The Great Egret, for example, shows green facial lores next to its bill only during courting season.

Some birds posture, strut, and dance in ways that have long captivated humans as well as other birds. Some Native American dances were based on the strutting of prairie chickens. The bowing and curtsying of European society is also likely based on the behavior of birds.

Courtship is ritualized, and in nesting colonies, prescribed behavior quickly identifies the flying-in bird to the sitting bird. The greeting ceremony provides good photographic opportunities, as long as the photographer keeps a good distance away from the birds and uses lenses with long focal lengths. Photo blinds placed at a safe distance will increase your chances of getting good pictures.

There are too many horror stories about photographers disturbing nesting colonies. Imagine the damage a frisky pet brought along by its master can do in one romp through a colony of ground-nesting terns. Enemies such as heat, cold, and marauding gulls take enough toll without any help from humans.

There's so much to photograph in this magic time. Awareness of the birds' well-being will only increase your enjoyment.

—Bates Littlehales

The Gray Jay's courtship might be more subtle than that of many other species of birds, but it is still very photogenic. Look for pair bonding in other seasons as well.

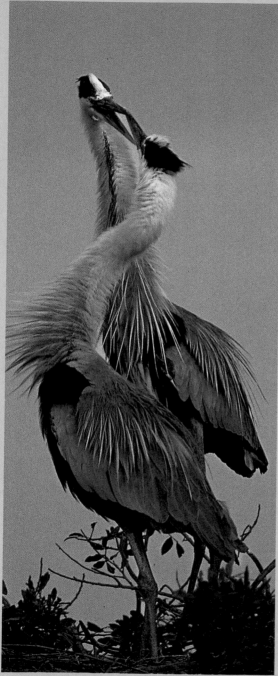

These antics (left), part of the greeting ceremony at a Great Blue Heron's nest, reassure the sitting bird that the flying-in bird is indeed the same mate that flew out. Shooting from across a pond, the photographer caused no impact on the colony.

The elaborate courtship ritual of Northern Gannets includes birds raising their bills high in the air. At large nesting colonies, plenty of opportunities exist for making courtship images. These birds allowed the photographer to get close enough to use a 70-300mm zoom lens.

Bates Littlehales

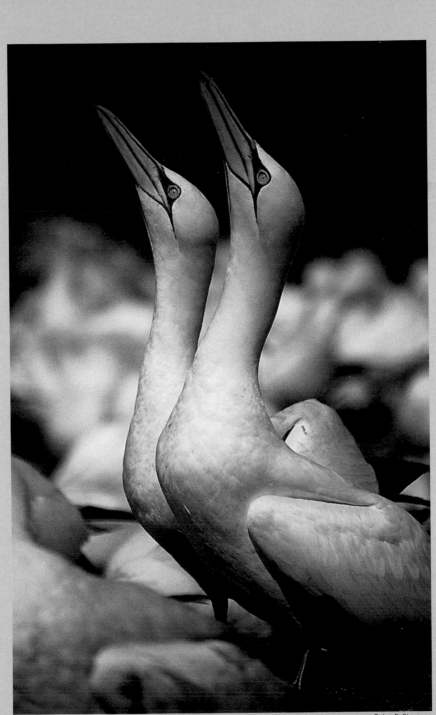

Rulon E. Simmons

Photography at Nests

GETTING PICTURES OF BIRDS at their nests usually requires setting up a blind. There are, however, some situations that can make getting pictures of birds at nests easier to take and don't require a blind. First, let's take a look at some of these easier cases.

Some birds, such as Killdeers and Horned Larks, nest on the ground and will often stay on their nests when approached. A friend of mine once photographed a Killdeer that had built a nest near the parking lot of a large company. When people came to work in the morning, they walked right past the bird, which stayed on its nest. My friend took advantage of the opportunity to photograph this cooperative subject.

Years later, I had a similar opportunity to photograph a nesting Killdeer in another backyard. A friend had taken photographs of the bird at close range with a 50mm lens.

I figured it would be easy to photograph this Killdeer. I armed myself with my 70-210mm zoom lens and marched right up to the nest with my curious children trailing behind me.

This, of course, proved to be too much for the bird, which took off from its nest and flew a short distance away. There it feigned a broken wing, a trick often used by Killdeer to lure predators away from their nests. I couldn't get near the bird that day.

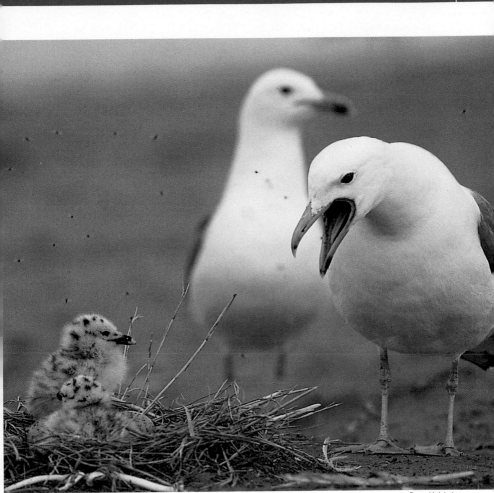

Bates Littlehales

The next day I returned and proceeded more cautiously. Pretending not to be interested in the bird, I slowly and quietly walked to a point near enough to get good shots with my 450mm lens. I was able to get some good pictures in this way without a blind.

Soon, the bird seemed to get used to my presence. A few times it flew from the nest, but it always returned, even when I stood nearby.

Though I meant no harm in my attempts to photograph this nesting bird, I have since

This nest of California Gulls, with newly hatched chicks, was photographed from a portable blind a safe distance from the action. Working this way, you can wait for telling gestures that add interest to the image.

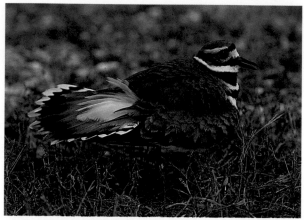

Bates Littlehales

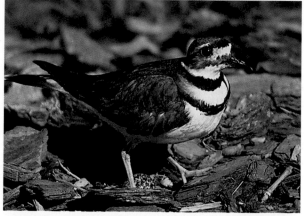

Rulon E. Simmons

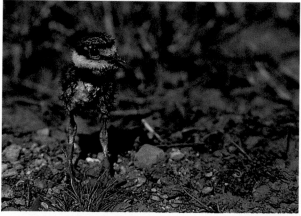

Bates Littlehales

learned to avoid doing things that might push a bird to leave its nest while it's sitting on eggs. In its broken-wing act, the Killdeer expended a lot of energy—energy needed for warming eggs. A little exploitation is unavoidable when photographing birds, but try to avoid "bad" exploitation.

Nesting Boxes

Photographing birds at nesting boxes can be relatively easy. I've photographed Tree Swallows and Eastern Bluebirds this way. My first experience photographing at a nesting box was with a pair of Tree Swallows that had moved into a box my son, Ken, had put up as part of an Eagle Scout project.

To get a natural-looking picture, I cut a slab off a log and nailed the flat side to the front of the box as a façade. I cut a hole to correspond to the original opening in the bird box.

The birds seemed puzzled when they first saw the modification to their house, but within ten minutes, they were flying in and out of it again. I set up a flash near the box and photographed the birds from about ten feet away, using a 600mm lens. I even took some pictures at closer range with my 70-210mm zoom lens.

The following year, I used the same façade on a different box for photographing bluebirds. In photographing Tree Swallows and bluebirds, I put a blanket over my head to hide myself from the birds. I soon found that this wasn't necessary— at least in the case of the Tree Swallows.

Tip

A nesting box or cavity can be used to make action shots by remote control as the bird leaves the hole. Prefocus, then start your motor drive when the bird's head emerges.

Killdeers will tell photographers and predators they are too close by doing the wounded-bird act to lead them away from the nest. All plovers, and also some other ground-nesting birds, exhibit this behavior. The precocial Killdeer chick, never far from its protective parent, relies on cryptic coloration for camouflage.

Seabird Colonies

Colonies of seabirds can offer many interesting opportunities for photographs at nesting time, but before you set out for these sites, it's best to check with bird-banding groups to find out the best and least disruptive time to take photographs. Many such nesting areas are on islands accessible only by boat—and even boats have to keep their distance.

Some nesting colonies suffer badly from visits from humans and their pets. Eggs and young can be harmed by the sun when their parents fly off the nest in fright. Predatory gulls seize such opportunities to devour the eggs or young birds.

Finding Nests

Now that we have discussed some of the easier situations for photography at nests, let's look at more typical—and more challenging—situations. First, you have to locate a nest. This usually requires a good pair of binoculars, careful observation, and patience.

Friends can also provide useful leads. It is a big help if the nest is conveniently located, but many are not. The persistent photographer may have to build a scaffold to the proper height for picture taking. Whether or not a scaffold is necessary, you'll probably need a blind.

When possible, it's best to build a blind over a period of time so that the change in the birds' environment will not be too abrupt. As an alternative, you can construct a blind at some distance from the nest and then gradually move closer. This starting point should be beyond the flushing distance of the bird.

With small birds like warblers, it may take as much as a day to move the blind into position

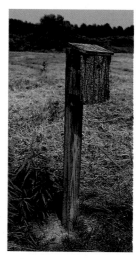

A nesting box with its face cut from a log provides a natural-looking backdrop for photography.

When the photographer added a natural-looking log façade to an existing entrance for a nesting box, the female Eastern Blue-bird (opposite) readily accepted this change to its living quarters.

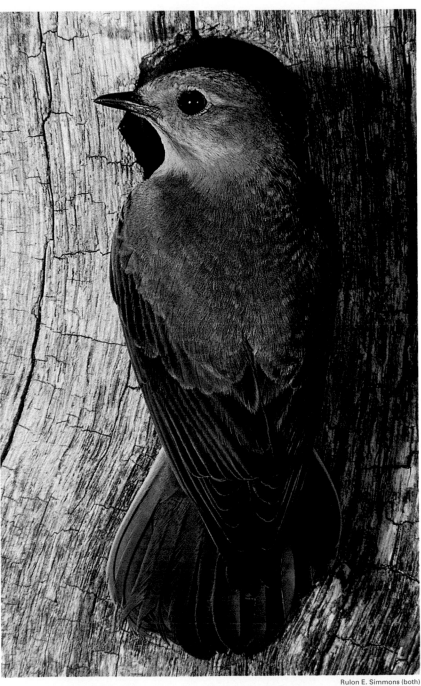

and get it ready for photography. With larger birds like hawks and herons, it may take a week or more. A fake camera and flash can also be positioned to get the birds used to the intrusion before you begin to take pictures.

As you make each change, back off and observe the parent birds' behavior through binoculars to make sure that the birds will return to the nest.

A trick that can be very successful in photography at nests is to have a "go awayster." This is a person who accompanies the photographer to the blind, but then leaves, making enough noise so that the birds take notice of the exit.

Most birds are believed to be unable to count. When one person leaves, the birds think no one is left in the blind, so they return to the nest much sooner. For this trick to continue to work, the bird must not recognize that it has been tricked. In order to maintain the deception, the "go awayster" must return to retrieve you. A handkerchief can be used as a signal for the helper to return.

Remote Photography

Another technique for photographing nesting birds is to position your camera close to the nest while positioning yourself some distance away with a remote release. In some cases, you may find that you will need to conceal yourself as well as you can.

Remote photography will allow you to take pictures of birds with minimal disturbance to

Tip

Don't be in a hurry to tackle nest photography—it takes preparation and expertise. People who have been the least intrusive—and most successful—have studied for years.

Lesser Snow Geese nests (opposite, all). The photographer accompanied an ornithologist, who weighed and tagged goslings while their parent geese waited nearby. The birds were quickly photographed, then left alone.

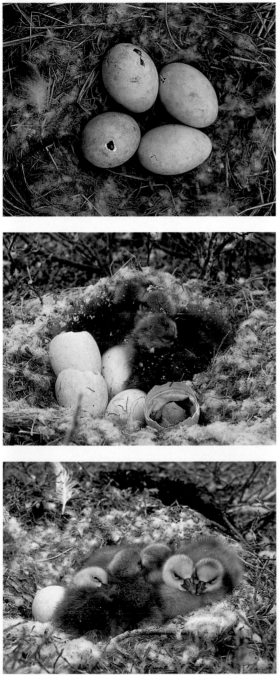

Bates Littlehales (all)

FOLLOWING PAGES: To get this image, the photographer spent days in a tent blind watching a TV monitor that was wired to a videocam high in a pine tree near the Bald Eagle nest. When the adult showed up on the screen, the photographer punched a button, which fired a motor-driven still camera mounted by the video-cam. The bird's widely spaced nest visits made for tedious days that started early and ended late. The photographer had to enter and exit the blind in pitch darkness; sharp-eyed eagles are not tolerant beings.

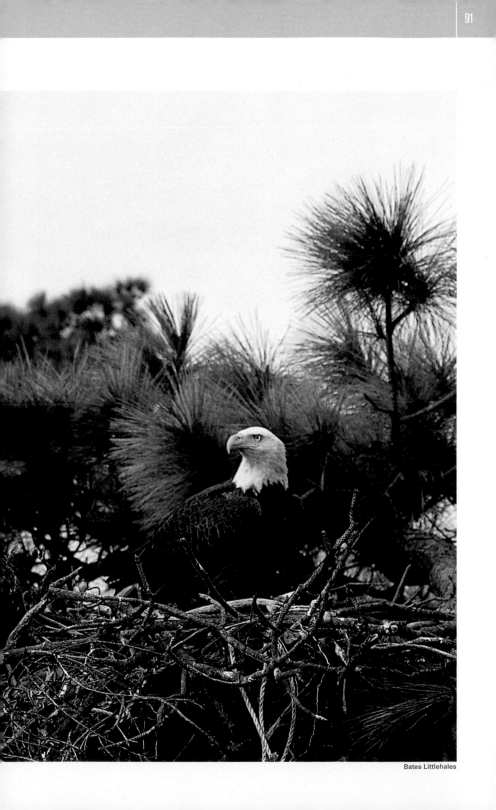

Bates Littlehales

Bates Littlehales

Cactus Wrens build one false nest after another, giving the photographer plenty of opportunity to catch them in the act.

them. From a distance, you can release the shutter by means of a mechanical shutter release, a wired electrical release, or a radio-controlled release.

Cameras with automatic film advance are desirable for such photography, since they minimize disturbance of the birds. They also provide for uninterrupted opportunities to take pictures.

A larger-format camera can be useful for remote photography. It is difficult to frame a tight 35mm shot, since the exact position the bird will take is somewhat unpredictable. The larger image area permits cropping after the picture is taken.

Unpredictability of the bird's position can also lead to focus problems. Observe the bird's behavior before setting up the camera so you'll be able to anticipate what will happen. Those who relate to the bird have the best chance of success when adjusting the camera focus.

Using Flash

You can get away from problems created by variable natural lighting by using flash. If lighting conditions are changeable, an automatic exposure control will also be necessary. Nests are usually found in shaded areas of vegetation where flash may be required anyway.

When you set up your flash units, place one flash as a main light source somewhat above the nest. Angle the light to make the bird's shadow fall low so that it does not hit the vegetation directly behind the bird and create a dark shadow in the image.

A weaker flash with about one stop less exposure, when used as fill flash, can lighten shadowed areas on the bird. Sometimes you'll need a light on the background as well to keep the background from going too dark.

The Well-being of Birds

Whenever you are photographing at nests, be particularly conscious of the birds' welfare, avoiding any unnecessary disturbance. At times, this may require backing off and missing a picture, but there will be others.

Don't just march up to bird nests the way I once did and start taking photographs. You should approach the birds in a way that doesn't startle them.

Do some research before you set out with your camera. Talk to wildlife experts—refuge

Tip

Unlike birding, bird photography is a solitary business. Resist human companionship in the field and concentrate on relating to the bird.

managers or biologists—about the least intrusive ways to photograph nesting birds and the best times for it.

Altricial Birds

For altricial birds, those born without feathers, it is safest to wait for at least five days after the young have hatched before you begin to take pictures. There's no need to rush—there will still be plenty of time to take photos as the parents feed these birds.

After the young have hatched, parent birds have strong instincts that draw them to their young. You can set up a blind earlier, but birds may abandon their nest if you begin to photograph too soon. Once the young birds get close to fledging, photography should be terminated so as not to cause premature fledging.

Precocial Birds

The strategy is a little different with precocial birds, which are born with down and leave the nest area within a few hours of hatching to learn to feed themselves.

Photography has to begin somewhat earlier. Even so, the blind should not be set up until the parent birds have been incubating for at least a week.

Tread Lightly

Even careful photographers can cause nesting failure in their attempts to get good pictures. Predators, for example, will sometimes follow the photographer's trail of trampled grass right up to the nest.

To help ensure the birds' well-being, there are other cautions to observe. Never cut away branches to expose a nest. Some branches can be tied back temporarily with string, provided that the nest is not exposed to either direct sunlight or the view of predators.

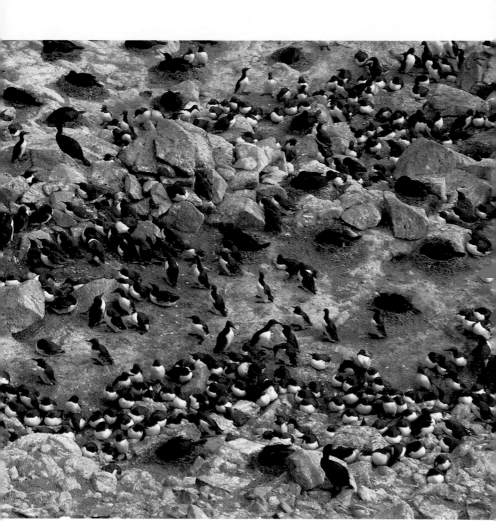

Bates Littlehales

After making any changes around the nest, back off and observe the birds to make sure they accept the changes. If they don't return to their nest soon, do your best to restore the area to its original condition and leave the area. Getting a photograph you were after isn't worth endangering your subject.

You'll have plenty of chances to take great photographs of birds without putting either of you in jeopardy.

The photographer stood on a cliff to get this image of a nesting colony of Common Murres and Pelagic Cormorants on an island off the California coast, stopping down his telephoto lens to keep the scene in focus.

Blinds

SOME TECHNIQUES DISCUSSED IN this book require hiding from birds. This is usually best accomplished with a blind. Blinds are useful at nests, feeders, or any other areas regularly visited by birds. They may be portable for use in the field, or permanent, as found at some wildlife refuges. Sometimes, even your car or home can serve as a good blind.

A makeshift blind can be made from natural materials such as branches or reeds. As you become more involved in bird photography, you may want to construct a portable blind. The diagram on the following pages illustrates an easy-to-make blind using inexpensive PVC tubing, bungee cords, and fabric. Burlap is a good material for covering the frame because it allows air to pass through, minimizing heat buildup inside.Camouflage cloth is another good option.

Small dome tents, which are particularly easy to assemble, make effective blinds for birds on or near the ground. A refrigerator carton can be transformed into a temporary blind, but you'll have to make a few holes for ventilation as well as for your lens.

It helps to make the blind blend as well as possible into the natural surroundings. For this reason, greens and browns are usually the preferred colors. For particularly wary birds, covering the blind with branches or other natural vegetation may also be necessary.

Another simple and effective method of

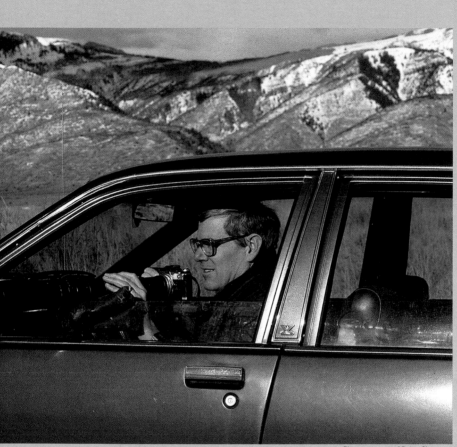

Photo courtesy of Rulon Simmons

hiding is to sit quietly under camouflage netting. The netting is easy to use and allows good air circulation. If you have to move, do so preferably when birds are not present. Otherwise move as slowly as possible so you don't attract the attention of the birds.

When you position your blind, keep in mind the lighting direction and how the light will change while you are in the blind. Also consider the most likely flight path of your subject and where the bird will land.

Whenever possible, enter and leave blinds when birds are not present, thus minimizing

Author Rulon Simmons demonstrates the use of a car as a blind. This can be an effective way to get close to birds, which are usually less wary of a person in a car than one on foot. Note the beanbag placed in the open window to help stabilize the lens.

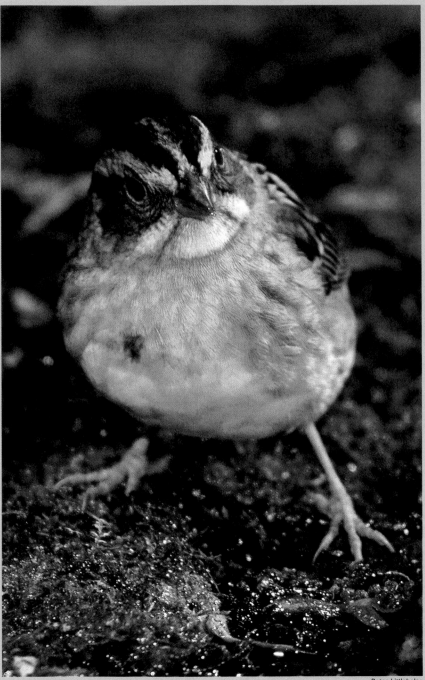

Bates Littlehales

disturbance. For long stays in a blind, take a stool or chair and anything else that will make your time there as comfortable as possible. You could be waiting a while, so consider taking a good book to read.

At times, the best blind of all may be your car. Birds seem less afraid of cars than of people on foot, and will often allow vehicles to get fairly close. Approach slowly, without making sudden moves. When you're in a good position, you can turn the car engine off.

When I take photographs from my car window, I occasionally place a piece of cloth over the window to hide behind. Even that is usually unnecessary, as long as I don't make any quick movements.

Many wildlife refuges are particularly well suited to photographing birds from a car. They often have roads that loop around ponds and other bodies of water where you can find birds feeding, particularly in the early morning and late afternoon.

Birds on the ground and in trees, particularly along wildlife refuge roadways, are often fairly easy subjects to photograph from a car. If you drive up slowly while a bird is feeding, it will often continue without much concern. If it does fly away, be patient—it may return in a few minutes to get back to work.

A beanbag or even a folded jacket makes a good window rest for a long lens, and will help absorb vibrations. Manual windows, if your car has them, work best, since they can be slowly raised and lowered at any time, even when your car engine is off.

As you can see, many options exist for blinds. Choose one that meets your needs, and you'll soon be very close to birds.

—Rulon E. Simmons

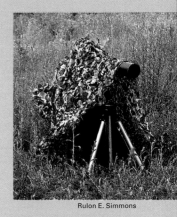

Rulon E. Simmons

A lightweight camouflage net makes an instant blind when draped over the photographer. Always avoid any quick motion that could frighten birds.

A wintering Whitethroated Sparrow was an easy mark from a backyard blind. A good trick when using flash on a shot like this is to light the area—not just the moving bird.

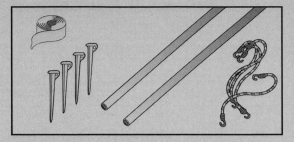

Left to right; duct tape, four tent pegs, two 132-inch lengths of 1 1/4-inch-diameter PVC tubes, four bungee cords

How to Make a Blind

The perfect portable blind does not exist commercially. Some come close, but are expensive. This design can be modified with little trouble. For floating, it can even be customized to fit a truck inner tube. Peep holes and camera ports can be sized to suit the photographer and equipment.

For your backyard blind, use two 132-inch lengths of 1 1/4-inch-diameter PVC flexible tubing. For easier portability in the field, use four 66-inch lengths and two wooden dowels that match the inner diameter. Cement one end of each dowel into one end of a 66-inch length, then put the two 66-inch lengths together on the work site and tape the joins. Heavy, long nails will work as well as tent pegs.

Light cotton camouflage cloth, which usually comes in a 44-inch width, makes excellent cover, and cammy netting can cover the peephole or holes. Cotton is lightweight for carrying long distances, is breathable, and doesn't show the photographer's silhouette when backlit. Drape the uncut cloth over the assembled blind frame and use chalk to draw the shape. Cut four arc-shaped pieces. Sew together except for the entrance, which will close from inside with Velcro.

—Bates Littlehales

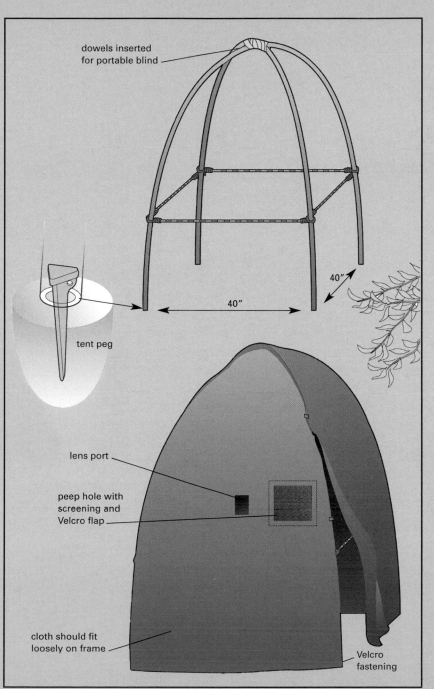

dowels inserted for portable blind

40″

40″

tent peg

lens port

peep hole with screening and Velcro flap

cloth should fit loosely on frame

Velcro fastening

Stuart Armstrong

The Wonders of Flight

WHO HASN'T MARVELED AT the graceful flight of a bird? Capturing this grace in photographs is perhaps the most challenging and rewarding aspect of bird photography.

My earliest successful attempt at photographing birds in flight took place on a boat returning from a trip to Martha's Vineyard. People on the boat began offering food to Herring Gulls, and soon a number of the birds were hovering just overhead. This provided an excellent opportunity to photograph them while they were nearly stationary.

The slow motion of these birds was important to my success, since at that time my photographic equipment was quite limited; I simply used a manual-focus 100mm lens. As the gulls hovered above, I could easily focus on them. Had they been flying by at full speed, focusing would have been very difficult, if not impossible, for me.

My friend Brian Keelan has used another trick for getting successful pictures of birds in flight. His method works well with cameras that have motorized film advance. He makes a through-focus series of photographs, continually changing focus as he shoots pictures of a passing bird. This technique uses a lot of film, but it usually produces one or two good images when the focus is just right.

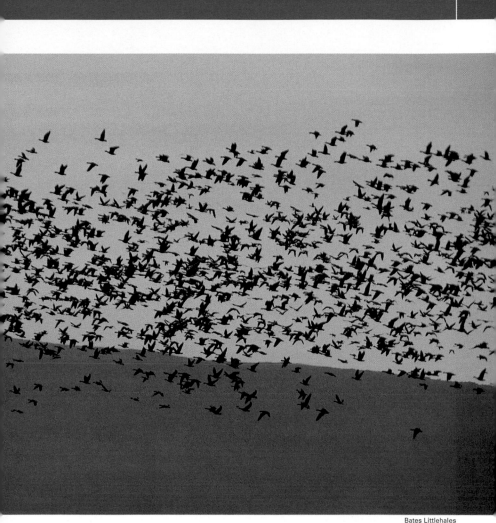

Bates Littlehales

Autofocus Lenses

In recent years, autofocus equipment has become very popular with photographers. What a difference it can make in flight photography! When I bought my first autofocus camera and lens, a whole new world of bird photography suddenly opened up to me.

Most manufacturers produce autofocus lenses with camera systems designed around them. With autofocus, be sure to check your

Like calligraphic writing across the sky, a flock of geese silhouetted against a simple background makes a dramatic statement.

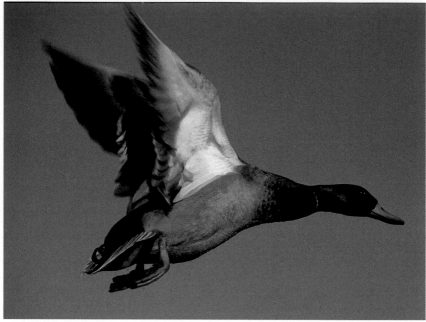

Rulon E. Simmons

The photographer used an autofocus 70-300mm zoom lens to capture this Mallard in flight. For an overhead shot of a bird in flight, there is little time to frame the bird.

manual to learn the different focus modes. The most common mode is to focus on the center of the frame. As a bird approaches, establish the focus by pushing the shutter release part of the way down.

The one drawback of autofocus lenses is that if the bird is extremely out of focus at first, the lens may have a hard time determining the correct direction in which to drive the focus. I try to have the camera prefocused at the approximate distance at which I expect to pick up the bird in my viewfinder.

Once your camera is focused, you will have to keep the shutter release partially depressed to maintain the focus as the bird continues to move. Some advanced autofocus lenses will actually predict the proper change in focus based on the relative motion of the bird and the camera.

Getting Started

Once you have a good handle on how to use your autofocus, you are ready to give flight photography a serious try.

I suggest starting with easy birds, such as gulls. Take a helper with a loaf of bread to a nearby beach or garbage dump. Ever watchful gulls will come immediately when your helper holds up a piece of bread. Your biggest problem may be singling out one bird.

Even if you don't have an autofocus lens, you should be able to get some pictures of these birds. If you live in Florida or another location inhabited by Brown Pelicans, you may be able to find a bridge or boat harbor where passing pelicans can be photographed at fairly close range.

Photographing waterfowl in flight is generally a step up in difficulty compared to the situations just described. With patience, you can wait concealed in a blind for a passing duck or goose to come in close.

A large bay in Rochester, New York, partially freezes during most winters. Large numbers of ducks concentrate there, mostly Mallards, in small open pools near the shore. I've found that I can lure these ducks out of the water with cracked corn.

My wife, Rebecca, helps by scattering corn at the upper end of the boat ramp while I wait near the water's edge as the ducks march by. I then step onto the ramp, cutting off the ducks' ground path back to the water. As I move toward the ducks, they take to the air to return to the water, giving me an opportunity for close-up flight shots as they go by.

A nice thing about flight photography is that it gives you another option that may allow you to get pictures of a species that would otherwise

Tip

A photographer is a hunter, but one who doesn't kill anything. With your camera, lead your bird in flight the way a duck hunter leads his game bird.

FOLLOWING PAGES: Panning with this close-flying American Avocet was reactive, not planned. The focus was on the bird before it left the water, so there was no need to refocus in flight.

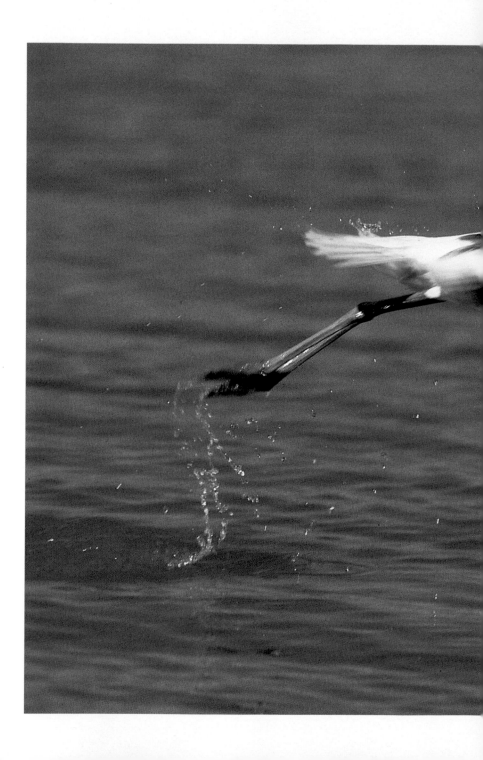

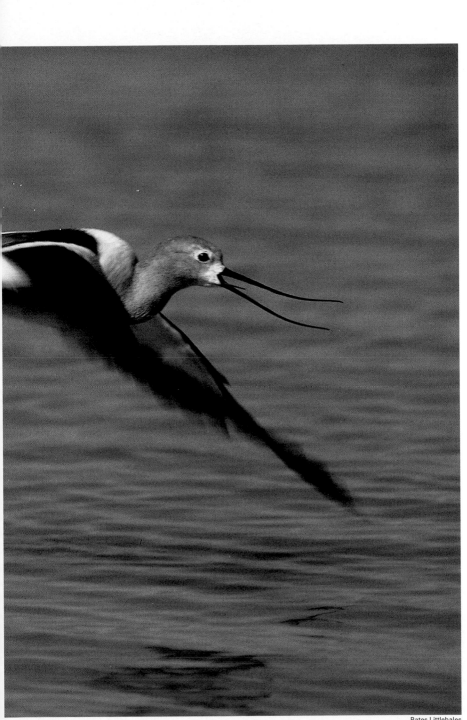

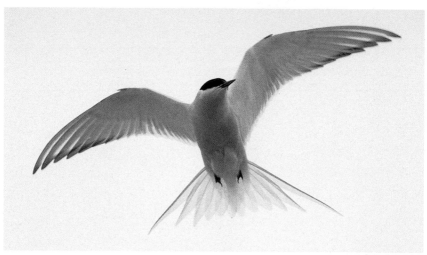

Rulon E. Simmons

Sky backgrounds often fool a camera's metering system into underexposing the subject. This Arctic Tern was photographed using an exposure reading taken off an object on the ground with average reflectance. When metering directly off a bird in a blue sky, give an additional 1/3 to 1/2 stop exposure to properly expose the bird. Give one or two stops additional exposure when the sky is white.

be very difficult to photograph. Once, on a trip to the Dry Tortugas, I was on a guide boat that was allowed to come in close to the nesting island, but not close enough for good photographs. Sooty Terns passing overhead gave me just the opportunity I needed.

When you're photographing birds in flight, keep in mind that the exposure can be tricky. White skies will fool most camera meters, requiring up to two stops or more additional exposure than metered. Furthermore, a dark bird against a bright sky will usually need an additional 1/3 to 1/2 stop exposure over the meter reading, while a light bird will need a similar decrease of exposure.

Unless you have a stabilizing lens, try to use a shutter speed of at least 1/125 second for flight

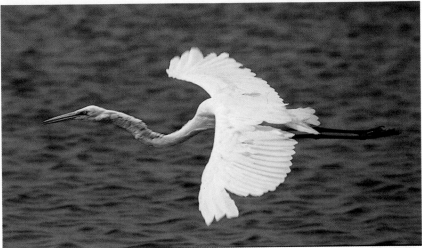

Bates Littlehales

shots. This will require using a fast lens and/or relatively fast film. An affordable f/4 lens can get good flight pictures with 200 speed film. Today's films in that speed range are very good.

Specialized Flight Photography

Some birds are either too small or too fast to photograph in flight using the preceding techniques. Birds such as songbirds are perhaps best photographed in flight by letting them photograph themselves.

The birds trip an invisible infrared beam as they fly through it. This requires setting up your equipment along a known line of flight, such as a bird's approach to a nest. Keep in mind that some delay will occur between the breaking of the beam and the release of the shutter. It usually takes a little experimentation to get everything set up just right.

This kind of photography is best done in shade so that the flash will be stronger than the ambient light, thereby helping to freeze the motion of the bird.

Moderately slow fliers like the Great Egret are much easier to shoot than smaller, faster birds. The contrasting background of open water also helps make this photo effective.

Tip

As in real estate, it's location, location, location for flight shots with a decent background. Aim for good light direction, room to swing the camera, and, above all, the location that will provide the most chances for finding the most birds.

In Different Light

WHILE TRAVELING, I always imagine sunny, blue skies greeting me at my destination. But when I get there, the weather always tells its own story. It might be overcast, or even stormy. So I have learned to be flexible and to try to make the most of any lighting situation when taking photographs of birds.

Early morning and late afternoon light provide pleasing lighting for bird photographs. But pictures taken in different light—sunrises, sunsets, or stormy weather—can be more interesting. A photograph of a bird hunkered down in a gentle snowfall evokes winter's cold, a flock of

Glaucous-winged Gulls make their way through thick fog in this moody shot (opposite, top). Don't rely on your in-camera meter to render tricky lighting situations like this one.

Stormy weather and dramatic light provide a good backdrop for a Common Merganser (opposite, bottom).

Based on information from a friend, the photographer drove three hours to see this Great Gray Owl (left). A light snow was falling intermittently when he found the bird. The soft, diffused light provided by the overcast sky worked well with the contrast in the stripes and spots of the owl's feather detail.

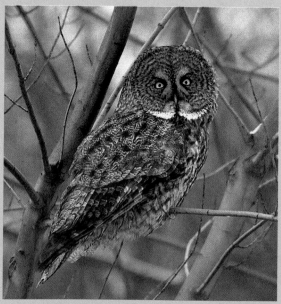

Rulon E. Simmons

Bates Littlehales

Rulon E. Simmons

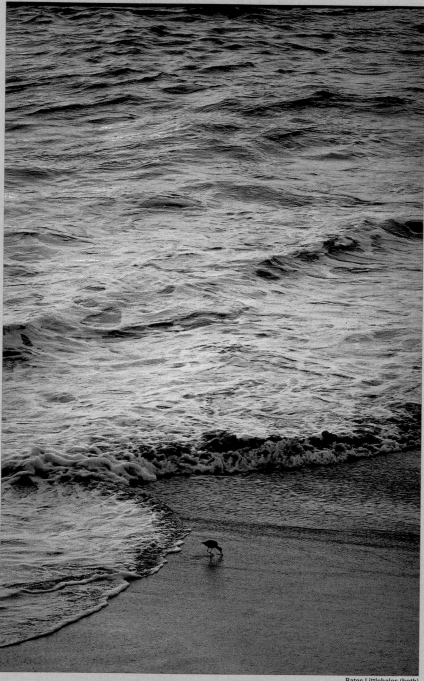

Bates Littlehales (both)

Don't put the camera away when daylight wanes. Two very different messages and moods were possible with the lone Willet on the beach (opposite) and the Canada Geese crossing a colorful sky (above). Neither image would have worked as well in mid-afternoon.

birds emerging from a fog bank conveys a sense of mystery. Even when a bird is relatively small in a picture filled with the dramatic light of sunrise or sunset, the image can be stunning.

Tricky lighting situations demand careful attention. In photographs with snow and fog, for instance, your best bet is to set exposure based on a close-up reading or a mid-tone rather than the whole scene. This will likely mean increasing the exposure by a stop or two to prevent an underexposed image.

—RULON E. SIMMONS

FOLLOWING PAGES: A dramatic sky was underexposed to produce a mood of tension animated by flying terns.

Bates Littlehales

Photographing on the Edge

EXCITING YEAR-ROUND POSSIBILITIES await the
observant and inquiring bird photographer.
Changing seasons, cold weather, and even night-
time each provide interesting opportunities.
Study bird behavior. Become familiar with the
day-to-day lives and travels of birds. Learn when
and where to expect certain birds. Learn under
what conditions birds are more approachable.
As you do, you'll figure out new ways to find and
photograph them, putting you on the edge
where you'll get pictures when others have put
their cameras away. Here are a few suggestions.

Migration

Still only partially understood, bird migration is
one of the miracles of nature. Long-established
patterns of migration, different for each species,
are faithfully followed year after year. Consider
the astonishing feat of Arctic Terns, which
migrate up to 22,000 miles round trip each year!
Then there are the tiny hummingbirds, which
make a marathon 500-mile non-stop crossing of
the Gulf of Mexico twice a year.

Take advantage of the transitory nature of
birds. With a little homework, you can find out
where various species are likely to be at any par-
ticular time. Many birds winter in southern
parts of the United States, including Florida,
Texas, and California, where winters are mild.

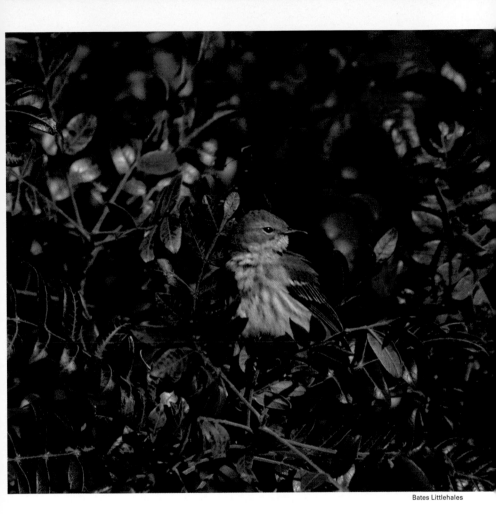

Bates Littlehales

During spring and fall migrations, trips to many of the nation's parks and wildlife refuges along the migratory routes can be very rewarding. Refuge managers and biologists will usually be happy to share their knowledge of local birds and provide you with a bird list for their area. You may not have to go far, either, as city parks are also good places to look for migrating birds.

Fall migration brings many shorebirds to the edges of Lake Ontario, giving me an opportunity to take photographs of species I wouldn't

The background foliage and fall plumage of the Palm Warbler proclaim autumn migration. The image would have been much less effective if the bird had been centered in the composition.

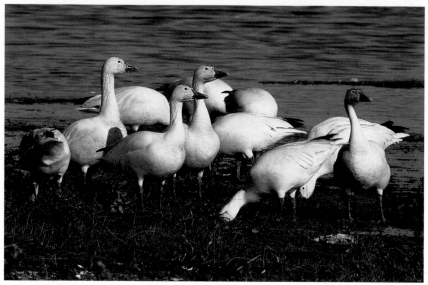

Bates Littlehales

One problem photographing Greater Snow Geese was cleanly separating them by composition from their much larger flock. Showing typical goose behavior, this group consists of feeders and alert guards.

otherwise have a chance to see. Mudflats, with a variety of edible crustaceans and aquatic insects, are also popular stopping areas for migratory shorebirds. Since mud is often difficult to negotiate on foot, make sure you have the right footwear for slogging across the flats.

The fall migration of most shorebirds starts in late July. In my hometown of Rochester, New York, migrating birds are seen in abundance in August and September. These birds are usually in breeding or juvenile plumages. A little earlier in the year, starting around the end of June in the northern states, smaller numbers of shorebirds in breeding plumage can often be found. These are birds that failed to mate and therefore started their southward migration earlier than the rest of the birds.

Considerably fewer shorebirds are seen during the spring migration than in the fall. This is due in part to high mortality rates they suffered during fall and winter. Also, in the spring, the

returning birds are in a hurry to get to their nesting grounds. For both reasons, you are not likely to have as much opportunity to photograph shorebirds in the spring as in the fall.

There are exceptions, though. When horseshoe crabs lay their eggs in May along Delaware Bay, huge numbers of shorebirds come to feast on the eggs. Wherever you do find them, spring birds are often decked out in their striking breeding plumages.

During migrations, the birds tend to be less secretive than during the nesting season. This makes photography much easier.

Many excellent places for migrating shorebirds are found along the Atlantic Coast, Cape Cod and Long Island being particularly notable. At certain places along the migratory routes, birds must make long non-stop flights over large bodies of water. After traveling these long distances, some birds, particularly passerines like the Chestnut-sided Warbler, are tired and will land to rest. When this occurs, a careful photographer can approach birds that would otherwise be very wary. Try not to scare an exhausted bird by coming too close too fast.

Night Photography

Many birds that are unapproachable during the day can be readily approached after dark. My first experience with this phenomenon occurred when, as a kid, I went on a grouse-banding expedition with my father.

We used a generator-powered spotlight in the search for birds. That night, I learned that when a light shines into a bird's eyes, the bird will freeze. In many cases, you'll be able to walk right up to it. If you use this technique, do so only on a limited basis. Diurnal birds cannot make up

Tip

Captive situations offer great opportunities to photograph wildlife. Go to a rehabilitation or nature center to find wounded birds that can't be released. Don't pass up opportunities to shoot these just because they're not in the wild. You can make some striking portraits.

their sleep. During extreme weather or during the demanding breeding season, disturbance caused by photography can have serious consequences. This technique is much less disturbing to nocturnal birds.

Years after the grouse-banding expedition, I used a similar approach to photograph Barn Swallows that I had found nesting under a bridge that crossed a stream. During the daytime, any attempt to get near the birds was met with a rush of wings as the birds scattered from their nests. The situation was dramatically different after dark, when many of the birds could be approached to within inches as they sat on their nests or bridge supports. It was, nevertheless, necessary to move slowly so as not to frighten the birds.

The challenge of getting good pictures of the Barn Swallows was just beginning, however, once I discovered that I could indeed get close to them. I needed to work out suitable lighting for the pictures and a more stable platform from which to work than my canoe provided.

For lighting, I used an electronic flash on each side of my camera. I needed the second flash to prevent dark shadows on the structure behind the birds. For this flash, I used my underwater unit, which has a built-in slave.

To create a more stable platform, I strapped two canoes together with a plank across the top upon which to stand. This gave me good stability and got me up high enough to see more than just heads peering over the nests. It also helped me limit the amount of galvanized steel showing in the background.

I looked for a nest in front of a rusty section for a more natural look. From the pictures, you would never guess that they were taken at night. I used the same technique to photograph an

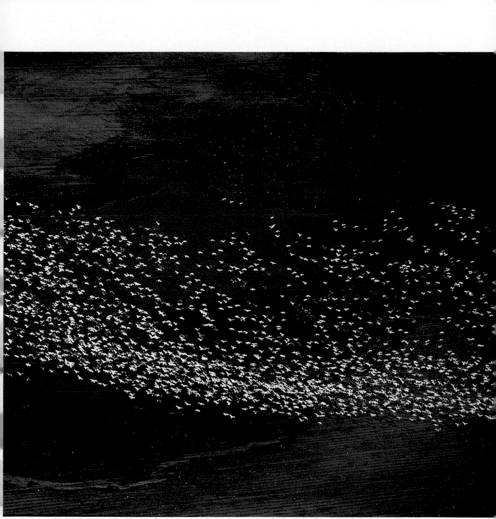

Bates Littlehales

Eastern Phoebe that I found nesting under another bridge. Fortunately, this phoebe's nest was low enough to photograph easily from a single canoe.

Whip-poor-wills and other nightjars are nocturnal birds. Where common, these birds can be located at night by watching for their shining eyes. Once you have located them, you can often approach them quite closely using a spotlight. I have used this approach successfully with Common Pauraques at Bentsen State Park in Texas.

The photographer followed these Snow Geese in an airplane long enough to capture the drama of fall migration.

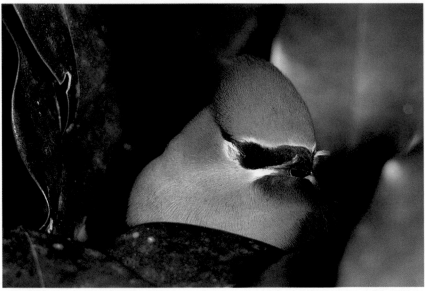

Bates Littlehales

A Cedar Waxwing (above) spent New Year's Eve sleeping outside the photographer's living room window. The extremely high-speed flash that made the picture possible didn't disturb the bird. The eyes of nocturnal Common Pauraques and other nightjars glow in a beam of light, giving away their presence. By shining a light in a bird's eyes you can often make a close approach (below).

Rulon E. Simmons

Cold-Weather Photography

Birds that are very active and difficult to
approach under normal conditions may be more
approachable during severe winter weather. This
includes songbirds that stay year-round in
northern climes. Northern Cardinals, for
instance, fluff up feathers over their legs and feet
to keep warm. In this condition, they are less
likely to take flight when they are cautiously
approached.

Sometimes in the middle of a harsh winter
you can find a stream or other body of open
water that will attract a considerable number of
birds. Water birds such as ducks are consistently
found in such places. Excellent opportunities for
photography abound when limited open water
forces birds to congregate in small areas.

Cold weather also enhances the attractiveness
of your bird feeders and birdbaths. Heated bird-
baths provide hard-to-find shallow water suit-
able for drinking and bathing. In winter, when
other food is scarce, my children and I have fed
Black-capped Chickadees right from our hands!

Care of Your Equipment

Winter conditions demand a little extra atten-
tion to the care of your equipment. For reliable
operation, be sure to keep your camera reason-
ably warm. The batteries will work more effi-
ciently, and there will be less likelihood of
mechanical problems. In extreme cold, film can
become brittle. In most situations, simply carry-
ing your camera and some film inside your coat
will go a long way to avoiding problems. Take
your camera out when you need it, and tuck it
back in between shots.

An external battery pack is another option for
many cameras. The pack goes in an inside

Tip

Lash a small flash-
light under your
camera or on top of
the flash to help
you focus at night.

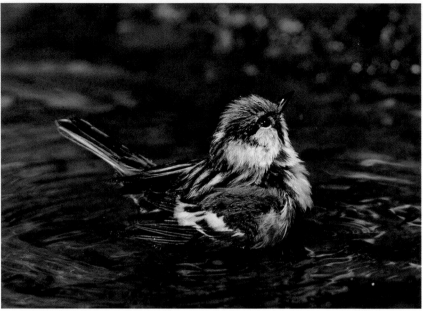

Bates Littlehales (both)

Male Chestnut-sided Warblers were photographed during spring migration (above) and fall migration (opposite). High-speed flash stopped the action in both images. A bird's year offers endless opportunities for great photographs.

pocket close to your body to keep the batteries warm. A power cable that runs to the camera can be threaded through a buttonhole.

Protect against condensation, too. When your camera has been in the cold for a while and you bring it inside to warmer, more humid conditions, condensation can form on the lens. To prevent problems, seal your camera in a plastic bag before taking it into a heated area. Let the camera warm up, then remove the bag.

For necessary dexterity to operate the shutter release in cold weather, I use a glove without fingertips. In extremely cold weather, a thin silk or cotton glove worn under the glove with missing fingertips offers extra warmth.

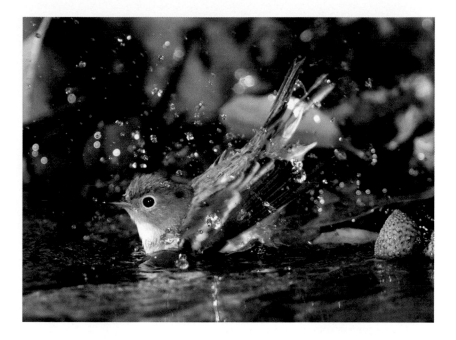

Hot-Weather Photography

When the weather is hot, your best opportunities for bird photography will often be early in the morning or later in the evening, when relatively cool temperatures prevail.

If you have to be out during the hottest time of day, be sure to take care of yourself. Drink plenty of fluids, wear a hat with a brim, and wear sunscreen. Take mosquito repellent. You'll probably need it in the watery environments where you'll be most likely to find birds.

Year-round Photography

Time of year plays an important part in determining the subjects you will find. Whether you choose to travel or stay at home, you can find abundant opportunities for bird photography throughout the year. Here's a year-round

Tip

Drip pools are especially attractive during migration, when the birds have been flying long distances.

scenario for bird photography that will apply to many areas of the United States.

Spring

Spring, a season with all sorts of photographic possibilities, is characterized by dramatic breeding plumages, singing birds, and an increased variety of birds showing up at feeders as spring migration gets under way. Remember to check nearby lakes and ponds for spring migrants.

Start watching for nesting birds in the spring and continue looking for them into the summer. During the nesting season, you could try luring some common birds with birdsong recordings. Check the regulations in the areas where you want to take pictures before you go.

In some places, luring birds with recordings is illegal because it can chase birds from their habitats. Over-eager birders, playing recordings in order to see a bird, can have a detrimental effect. Avoid being part of the problem by minimizing the use of recordings to lure birds.

Summer

During the summer, birds such as Mourning Doves, House Finches, American Goldfinches, various sparrows, and grackles continue to come to feeders. Don't expect to see as many different kinds of birds as in winter or during migrations, however. On summer trips, plan stops for photography at national parks and wildlife refuges.

Toward the end of summer, most birds molt, gradually losing their old feathers and getting new ones. The birds can look pretty ragged at this time of year, but they can still make very interesting subjects for photographs.

Birds can be harder to find because they aren't singing. Since nesting activities have been completed, birds aren't singing for territorial defense and courtship. They must be careful

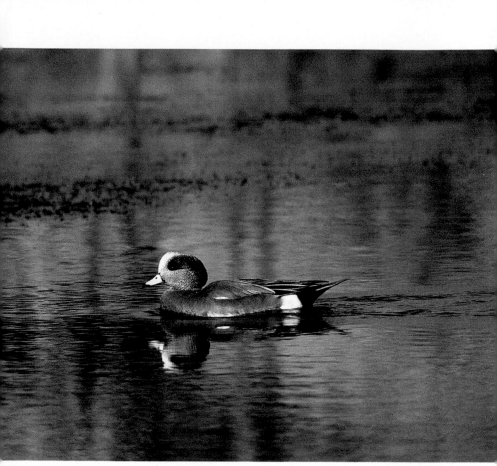

Rulon E. Simmons

during this time because they are more vulnerable to predators as their feathers molt.

Your best opportunities for bird photography at the end of summer may well be with migrating shorebirds found on mudflats, lake shores, or in freshly plowed fields.

Fall

In the fall, excitement builds at feeders again as the southward migration brings new birds to your neighborhood. Put out some suet when the hot days of summer have waned, and you will likely see a variety of birds. The list of visitors could include woodpeckers, chickadees, and

Reflected fall colors make a beautiful setting for this photograph of an American Wigeon.

FOLLOWING PAGES: Fresh snow simplifies an otherwise complex background, allowing a male Northern Cardinal to stand out as the center of interest no matter how small he is in the photograph.

Bates Littlehales

nuthatches, and others, depending upon where you live. Continue checking beaches, mudflats, and plowed fields for migrating shorebirds.

Winter

Don't put your camera away during the winter. There will continue to be a lot of activity at your feeders. The scarcity of food will bring new varieties of birds not seen at other times.

In the northern United States, winter species include birds such as juncos, nuthatches, chickadees, woodpeckers, and occasionally redpolls or other northern finches. A variety of different sparrows (e.g., Fox, Swamp, Song, White-throated, Vesper, Le Conte's, Savannah, and Grasshopper) choose to live in southern states during the winter. American Goldfinches, Purple Finches, and Red-breasted Nuthatches also frequent winter feeders in the South. On the West Coast, look for Golden-crowned Sparrows.

During the winter, also check beaches for gull species that may not reside year-round in your locality. Note that gulls that have black heads in the summer will lose the dark plumage on their heads during the winter, providing an opportunity for comparison shots. Look for Heermann's, Mew, Western, California, and Glaucous-winged gulls on western winter beaches. Keep in mind that in some species only the younger birds migrate as far south as California. In the East, expect to find Bonaparte's, Great Black-backed, and Laughing gulls. Ring-billed and Herring gulls are common along the eastern and western coasts of the United States.

As seasons change, as temperatures plummet, and as day turns to night, look for ever changing opportunities for bird photography. You should be able to photograph a wide variety of birds throughout the year.

No winner of a beauty contest during molt, this nearly bald, apologetic-looking Blue Jay nevertheless tells of the changing seasons. Note the insect-eaten leaves of August.

Juvenile plumage of the male Red-breasted Merganser (opposite) closely resembles that of the mature female. This image somehow conveys a jaunty look.

Bates Littlehales (both)

Favorite Locations

Not all good birding areas are good locations for photography. One of the best ways to get good close-up pictures of birds is to go to areas where birds are plentiful and used to seeing "friendly" people. Such areas include national, state, and local parks, national wildlife refuges, private sanctuaries, and public beaches.

Make your trip more rewarding by obtaining local birding guides. Note that some species listed for the following locations can only be found at certain times during the year. Check with field guides and local birders for current conditions and best times to see different species.

There are many excellent places for bird photography in the United States and Canada. Some of my favorites are described below.

Alaska

Kenai Peninsula

Kenai Peninsula has a variety of forest birds. In Homer, you can find Northwestern Crows, Glaucous-winged Gulls, Bald Eagles, and various waterfowl, including Trumpeter Swans.

Pribilof Islands

A flight to Saint Paul will get you to one of the best places in Alaska to photograph seabird colonies. Tour buses are the only means of

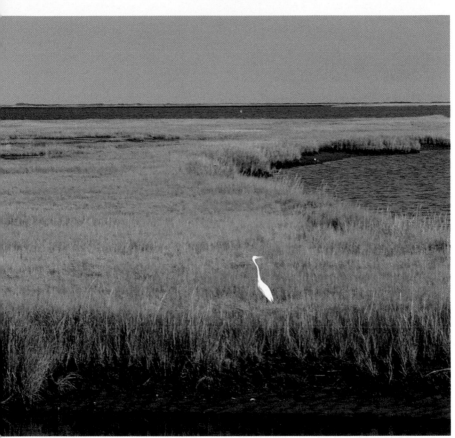

Bates Littlehales

transportation. The best seabird cliffs are on the southern edge of the island, at Ridge Wall and Southwest Point. You can photograph Common and Thick-billed murres, Black-legged and Red-legged kittiwakes, auklets, Horned and Tufted puffins, Northern Fulmars, Red-faced Cormorants, Rosy-Gray Crowned Finches, even Northern Fur Seals.

A Great Egret stalks the salt marshes of Delaware Bay. This much-photographed bird works beautifully as a center of interest in landscapes because of its contrasting white plumage.

Arizona

More than 300 species of birds are found in southeastern Arizona, some of which are found nowhere else in the United States.

Bates Littlehales

The Arizona-Sonora Desert Museum

On a one-day visit, I photographed Curve-billed Thrashers, Gila Woodpeckers, Gilded Flickers, Pyrrhuloxia, Phainopeplas, and Cactus Wrens. You can also photograph native birds in an aviary.

Madera Canyon

Madera Canyon is located between Tucson and Nogales. Birders come here to look for the rare Elegant Trogon as well as a variety of canyon woodland species.

A Green Heron perches by a pond in Everglades National Park. In many parks and refuges, birds are used to people and will allow photographers to approach quite closely if they do so in a calm and quiet way.

In summer, look for Black-chinned, Broad-billed, Blue-Throated, and Magnificent humming-birds. Try setting up a feeder at Bog Springs Campground. Photographic opportunities in winter are spectacular. You should be able to find Mexican Jays, Bridled Titmice, Yellow-eyed Juncos, Dark-eyed Juncos (Oregon and Gray-headed sub-species), Acorn Woodpeckers, and White-breasted Nuthatches at seed feeders at the Madera Lodge.

In grasslands below Madera Canyon, you can look for Cassin's Sparrow, Botteri's Sparrow, Rufous-winged Sparrow, and Varied Bunting. In rocky washes nearby, you may find the Buff-collared Nightjar (a rare Mexican species). Watch where you go and beware of rattlesnakes—I almost stepped on one!

Ramsey Canyon

Mile-Hi Ranch in Ramsey Canyon, run by the Nature Conservancy, has been described as the hummingbird capital of the United States. Twelve species of hummingbirds are known to visit this ranch. There's a bank of feeders near the Visitors Center, but they are not well positioned for photography. In the valley below Ramsey Canyon, I found and photographed Scaled Quail, Greater Roadrunners, and Curve-billed Thrashers.

Cave Creek Canyon

Scenic Cave Creek Canyon is near the town of
Portal. Acorn Woodpeckers abound; you may also
find Strickland's Woodpeckers. Many other birds
are found in this desert oasis. Several species of
hummingbirds frequent feeders in Portal and at
the Southwestern Research Station. Also check for
birds at Stewart Campground, Rustler Park, and
Cave Creek Ranch. Listen for the sounds of Elegant
Trogons at South Fork and along Barfoot Peak
Trail leading from the campground into the
canyon. At dusk, look and listen for Whiskered
Screech-Owls and Whip-poor-wills. In summer,
a hummingbird feeder set up at any of the camp-
grounds in the canyon should attract many species,
including the Blue-throated Hummingbird.

California

Tule Lake and Lower Klamath National Wildlife Refuges

Tule Lake National Wildlife Refuge and the nearby
Lower Klamath National Wildlife Refuge, near
the California-Oregon border, are excellent places
to find waterfowl, including Greater White-fronted
Geese, Snow Geese, Ross's Geese, Northern
Pintails, Mallards, Northern Shovelers, Cinnamon
Teal, Green-winged Teal, Canvasbacks, Redheads,
American Wigeons, Gadwall, Ruddy Ducks,
American Coots, and several species of grebes.
Ring-necked Pheasants and California Quail are
also plentiful along the roads. You will see eagles
here November through March, but probably won't
get close enough for good pictures. There are photo
blinds and a wildlife drive. October to November is
the best time to visit. At Klamath Falls, where the
river drains the Klamath Lake, you can get very
close to Barrow's and Common goldeneyes.

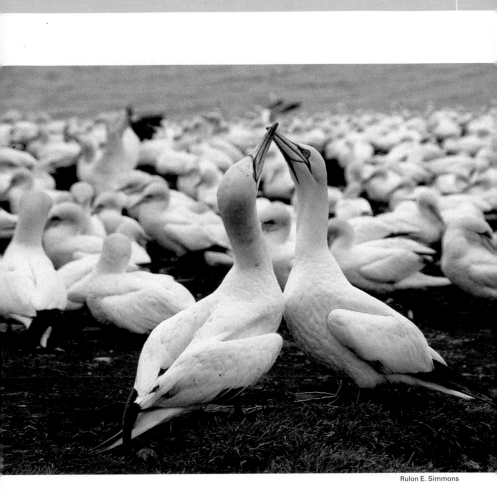

Rulon E. Simmons

Monterey Bay

Monterey Bay is an excellent place to find pelagic birds. In the harbor area, you should be able to photograph Brant's and Pelagic cormorants and Pigeon Guillemots. Pelagic boat trips that depart from this location can bring you close to shearwaters, jaegers, petrels, and more.

At Pt. Lobos Reserve State Park, located along the south shore of Carmel Bay, not far from Monterey Bay, and at Point Pinos in Pacific Grove, you will have a chance of photographing birds, including Black Oystercatchers, Black Turnstones, and Surfbirds.

Northern Gannets of Bonaventure Island, Canada, clap their bills together in a courtship display. Be prepared, then wait for the moment that can make a picture special. Patience pays off.

A Little Blue Heron resting in mangroves perfectly conveys the idea of a bird at home in its habitat. The photographer made this picture through a car window along a wildlife drive in Florida's Ding Darling National Wildlife Refuge.

Yosemite

Yosemite National Park offers spectacular scenery as well as great birding. I photographed Stellar's Jays at a roadside turnoff overlooking the valley. Look for Blue Grouse in isolated pine stands south of Olmsted Point. They are usually easy to approach and photograph. The Bridal Veil Campground area on the road to Glacier Point is one of the best areas for a variety of montane woodland species.

Los Angeles Area

About a mile northwest of the Los Angeles International Airport, Del Rey Lagoon is an exceptionally good place to find and photograph birds in winter. I have photographed Lesser Scaup, Buffleheads, American Wigeons, Red-breasted Mergansers, Pacific Loons, Long-billed Dowitchers, Willets, Spotted Sandpipers, American Coots, Brewer's Blackbirds, gulls, and hummingbirds there. A block north of Del Rey Lagoon, along a channel leading from Playa del Rey, look for gulls, terns, grebes (Western and Eared), Surf Scoters, Pelagic Cormorants, and various shorebirds such as Willets, Marbled Godwits, Whimbrels, Surfbirds, Black Oystercatchers, and turnstones (Ruddy and Black).

At Bolsa Chica Ecological Reserve, near Huntington Beach in Orange County, look for a variety of ducks, shorebirds, and terns. Expect to see Surf Scoters, Blue-winged Teal, Buffleheads, Northern Pintails, Ruddy Ducks, Lesser Scaup, Western and Eared Grebes, several kinds of sparrows, and a variety of shorebirds.

South along the Pacific Coast Highway, along Upper Newport Bay, I photographed three species of teal as well as American Avocets in mid-January. (I returned a month later and again found all teal species present.) Also within camera range were American Wigeons and a variety of shorebirds,

Bates Littlehales

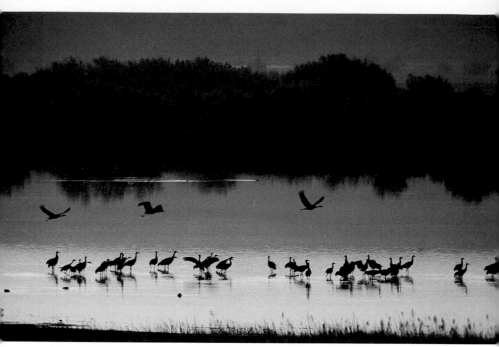

Bates Littlehales

Early morning light silhouettes a flock of roosting Sandhill Cranes as they leave for a day of foraging. Scout an area for birds, learn their comings and goings, and be ready to take advantage of photo opportunities like this one.

including a Long-billed Curlew. The uncommon Clapper Rail is a resident here. High tide is the best time to visit, as the higher water forces the birds closer to the road.

San Diego Area

Check San Diego Bay, particularly Strand Beach, for shorebirds. I got some nice Long-billed Curlew shots there. Ask about the biological study area at the southwestern end.

About two miles south of Silver Strand, Tijuana Slough National Wildlife Refuge is a good place to find shorebirds, waterfowl, gulls, terns, and photograph Savannah Sparrows. I also made some great pictures of a Say's Phoebe there one day.

The Mission Bay area is also a good place to find approachable shorebirds. Look for Willets, Whimbrels, and Yellowlegs. Gulls are also plentiful.

Salton Sea National Wildlife Refuge

A good area for photography is along Garst Road, leading to the Red Hill Marina. In season, look for nesting Great Blue Herons. At the Salton Sea, I've photographed Herring Gulls, Yellow-footed Gulls (common in summer and rarely seen at any other location in the United States), Black-necked Stilts, American Coots, Eared Grebes, Ruddy Ducks, Northern Shovelers, and Burrowing Owls, all from my car window. Burrowing Owls are found along the dikes and ditches of Sinclair Road, which leads to the refuge headquarters. Yellow-footed Gulls are fairly common in the summer and very rarely seen at any other location in the United States.

Colorado

Rocky Mountain National Park

For montane birds, visit Rocky Mountain National Park, where you can find Stellar's Jays, Mountain Chickadees, Broad-tailed Hummingbirds (and other hummingbirds during migration), Clark's Nutcrackers, Gray Jays, Western Wood-Pewees, American Dippers, and woodpeckers. White-tailed Ptarmigan, found above timberline along Trail Ridge Road, are difficult to find but tame. Park rangers can tell you where to look for ptarmigan.

Florida

Everglades National Park

Everglades National Park has great diversity of bird life, particularly large birds. Many birds are so used to people that they can be approached closely: Snowy, Great, and Cattle egrets, Great Blue Herons, Green Herons, Anhingas, Least Bitterns, American Bitterns, American Coots, Common Moorhens, Purple Gallinules, Turkey Vultures, Black Vultures,

Black-necked Stilts are one of the common shorebirds found at Salton Sea National Wildlife Refuge. This photo was taken along the refuge road, from a car. Keep in mind the direction and quality of light as you compose your pictures.

American Crows, Red-shouldered Hawks, Roseate Spoonbills, Pied-billed Grebes, Brown Pelicans, Black-necked Stilts, White Ibis, Wood Storks, and Black-crowned Night-Herons.

Look for Brown Pelicans near the fishing docks at Flamingo. "Head and shoulders" portraits are possible with a 100mm lens. Anhinga Trail includes a boardwalk into a marshy area where birds can be found at all times of the year. Frequently seen birds along this trail include Great Blue, Green, and Little Blue herons, American and Least bitterns, American Coots, Common Moorhens, Purple Gallinules, Pied-billed Grebes, and of course Anhingas. In spring, you have a good chance of finding birds nesting close to the trail.

Sanibel Island

A wide variety of waterbirds such as Anhingas, Yellow-crowned Night-Herons, Brown Pelicans, Wood Storks, Roseate Spoonbills, as well as various herons and ducks can be obseved at close range at J. N. "Ding" Darling National Wildlife Refuge. Turkey Vultures, Fish Crows, and Brown Pelicans are also common. Several Osprey nests are located in the refuge and at nearby locations. You can photograph from your car along a five-mile drive.

Dry Tortugas and Florida Keys

The Dry Tortugas, a group of tiny islets located 70 miles west of Key West, have drawn birders for years. Bush Key, Loggerhead Key , and Garden Key are the principal islets and can be reached only by boat or seaplane. I recommend going by chartered boat. Access to the nesting grounds for Sooty Terns, Brown Noddies, Magnificent Frigatebirds, and a few Masked Boobies is restricted. Boats are allowed in the surrounding water, though generally not close enough for close-up photos. Your best chance of getting pictures of Sooty Terns is to

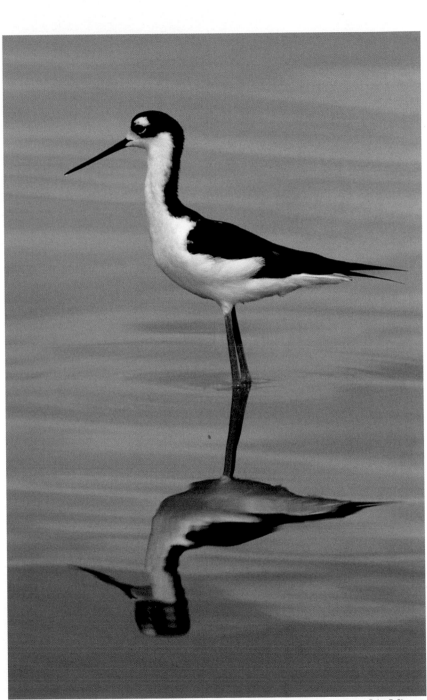

Rulon E. Simmons

photograph them as they fly to their nests. The easiest place to photograph Brown Noddies is at Garden Key, where they often line up on the rusting remains of an old pier. Frigatebirds ride thermals above Fort Jefferson. You can get close to them from the roof of the fort, which is accessible to the general public.

In late April and early May, look for migrating songbirds on Garden Key, particularly inside the fort. During or just after a storm, you may see dozens of different warblers, thrushes, and other songbirds weak from their long flight over water. During such a "fallout," exhausted birds can be easily approached and photographed. Water drips set up in the campground and inside the fort provide for excellent photographic opportunities.

Boat trips leave from the vicinity of Key West. Along the drive down the Keys, you may be able to photograph White-crowned Pigeons, Gray Kingbirds, American Redstarts, Blackpoll Warblers, and Northern Parulas.

Wakodahatchee

North of Miami, on the west side of Delray beach, Wakodahatchee is a new wetland and water-treatment facility, completed in 1996. In just a few years, it has attracted egrets, herons, Anhingas, and many other kinds of water and land birds. More than 140 bird species have been recorded at the site.

A boardwalk at the facility puts visitors close to the birds, making it an excellent location for photography. Least Bitterns (in season) and Purple Gallinules, uncommon birds in most Florida locations, can be easily found here. Also look for Limpkins, Green Herons, Least Terns, Mottled Ducks, American Coots, Common Moorhens, Red-winged Blackbirds, Tricolored Herons, and several species of egret.

Maine

Machias Seal Island

Machias Seal Island, located between Maine (U.S.) and New Brunswick (Canada), is a nesting site for Atlantic Puffins. There are photo blinds on the island, from which it is easy to photograph Razorbills, Atlantic Puffins, and Arctic Terns. Charter boats are available for travel to the island.

New Jersey

Edwin B. Forsythe National Wildlife Refuge

During migrations, the Edwin B. Forsythe (Brigantine) N.W.R. is an excellent refuge for shorebirds, including dowitchers, Whimbrels, Dunlins, and Black-bellied Plovers. Look for Clapper Rails along the canals. May and August-September are good times to visit. In late autumn, thousands of Snow Geese as well as Canada Geese can be found at the refuge. There are auto routes and photo blinds.

Bates Littlehales

The Scissor-tailed Flycatcher arrives in Texas in early spring. The bird sits in one place before darting after prey, making it fairly easy to photograph.

Cape May

Fall migration at Cape May can only be described as spectacular. Birds accumulate there during their southward migration, as they make their way to shore or prepare to make the 16-mile journey over the Delaware Bay. Passerines of all sorts can be found. The profusion of Northern Flickers makes for a remarkable sight. September is the best month to visit.

In spring, you can also find a variety of shorebirds, herons, gulls, and terns at Reed's Beach and Stone Harbor Point. At South Cape May Meadow, you will find shorebirds and herons. Piping Plovers and Least Terns nest there and can be photographed.

At Stone Harbor, located north of Cape May,

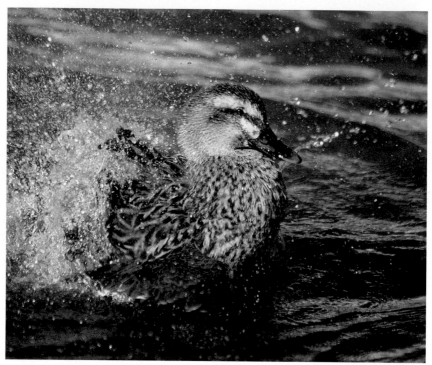

Rulon E. Simmons

Mallards are common in many city parks and ponds, such as Del Rey Lagoon in Los Angeles. Note that in the midst of all the frenzied splashing in this image, the bird's eye remains in focus.

herons can be photographed on their nests from a reasonable range. Snowy Egrets, Cattle Egrets, Great Egrets, Glossy Ibis, Black-crowned and Yellow-crowned Night Herons, Great Blue Herons, Tricolored Herons, and an occasional Little Blue Heron also roost there.

New Mexico

Bosque Del Apache National Wildlife Refuge

Bosque del Apache N.W.R. is the wintering ground for large numbers of Sandhill Cranes and Snow Geese. Ducks are also plentiful. The best time to photograph is from late November through early February. The first time I visited the refuge, in mid-November, there were approximately 6,000 Sandhill Cranes and 25,000 to 30,000 Snow Geese.

On my first trip, I was able to get pictures showing geese covering the ground like a carpet of snow. In winter, they come right up to the roads to feed on grain. I photographed snow geese at close range from my car and even got some shots of a lone Ross's Goose.

In spring, look for Western Kingbirds nesting near the Visitors Center, Ash-throated Flycatchers on low bushes, and Ring-necked Pheasants along the auto loop. Gambel's Quail are fed year-round on the east side of the Visitors Center. A small dome tent, which I set up about ten feet from the feeding area, worked very well as a blind.

New York

New York City Area

Nearly every kind of shorebird found in the eastern United States migrates through Jamaica Bay. Late July through early September is the best time for a visit. Brant are plentiful in winter.

On Long Island's southern shore, there are several good areas, including Jones Beach (where Common and Roseate terns nest), Fire Island, Moriches Inlet, and Montauk Point. June and July are the best times to visit.

Check Central Park for migrating passerines.

North Dakota

J. Clark Salyer National Wildlife Refuge

At J. Clark Salyer National Wildlife Refuge, you can photograph Franklin's Gulls (which nest there), Yellow-headed Blackbirds, American White Pelicans, and many kinds of waterfowl.

Look in grassland areas for Baird's Sparrow, Sprague's Pipits, LeConte's Sparrows, and Sharp-tailed Sparrows. Try the refuge blind in May for photographs of Sharp-tailed Grouse.

Rhode Island

Sachuest Point National Wildlife Refuge

Sachuest Point National Wildlife Refuge is noted for Harlequin Ducks, which reside here from November through April. Harlequin Ducks frequent rocky coastlines. With care they can be approached for photographs. The birds often swim very close to shore, but they always seem to stay just out of good camera range when they are in the water. I have had my best luck approaching birds that were resting on the rocks. Other birds to look for at Sachuest Point are Common Eiders, Common Goldeneyes, Buffleheads, Horned and Red-necked grebes, Red-breasted Mergansers, Common and Red-throated loons, and the three species of scoter.

South Dakota

Sand Lake National Wildlife Refuge

In March and early April, countless Snow Geese make a stop at Sand Lake National Wildlife Refuge, located northeast of Aberdeen. In August and September, this same refuge hosts several hundred thousand Franklin's Gulls, which stop there during their southward migration. American White Pelicans and various wading birds are also found at the refuge.

Texas

Padre Island National Seashore

Padre Island is a long, skinny barrier island extending from Corpus Christi, Texas, to the southern tip of the state. Road access is limited. Here, at Padre Island National Seashore, I was able to photograph Royal, Sandwich, and Least terns and an American

Oystercatcher using my car as a blind. Birding all along the Texas coast is good year-round, but the spring shorebird migration is particularly notable.

Aransas National Wildlife Refuge

Aransas is best known for the rare Whooping Cranes that winter there. To see the cranes, private groups run boat trips that last about four hours. The refuge Visitors Center has information on the trips. If you take a morning boat trip, you will usually have the best sun position for photography. In addition to Whooping Cranes, you may be able to photograph Roseate Spoonbills, many herons, Black Vultures, Turkey Vultures, and Caspian Terns.

Bentsen State Park

Feeders here attract South Texas specialties such as the Altamira Oriole. For photographing the Common Pauraque, the park is unsurpassed. Look for the bird at night along roads and grassy margins. They are easy to see because their eyes reflect car headlights.

Santa Ana National Wildlife Refuge

Santa Ana National Wildlife Refuge is noted for subtropical birds found in few other locations north of Mexico. The Plain Chachalaca, a chicken-like bird, is found here in abundance. Waterfowl and shorebirds are also plentiful. Other birds to look for include Least and Pied-billed grebes, Green Kingfishers (rare), American Coots, Common Moorhens, and Great Kiskadees. I have photographed Plain Chachalacas, Green Jays, White-tipped Doves, Altamira Orioles, and Black-crested Titmice at Santa Ana. A feeding station near the Visitors Center attracts many of these species.

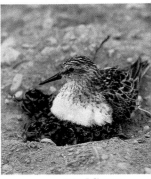

Rulon E. Simmons

This Semipalmated Sandpiper, tending her brood by the side of the road just outside Nome, Alaska, allowed close approach as the photographer moved slowly toward the bird with a 70-210mm zoom lens.

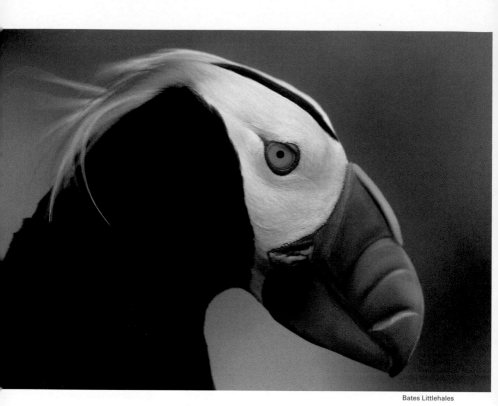

Bates Littlehales

Concealed behind a blind, the photographer shot this close-up portrait of a Tufted Puffin with a 600mm lens.

Virginia

Chincoteague National Wildlife Refuge

The refuge hosts Snow and Canada Geese, Laughing Gulls, Mute Swans, Yellow-crowned Night-Herons, Green Herons, Clapper Rails, shorebirds, and others.

Wyoming

Yellowstone National Park

Yellowstone provides opportunities for photographing Trumpeter Swans, Common Ravens, and Clark's Nutcrackers. Trumpeter Swans, now making a comeback from the brink of extinction,

are often seen along the Madison River. In Yellowstone, you can get close enough to ravens to obtain full-frame photos using a 600mm lens.

Stop at The Bridge bay picnic area for shots of Clark's Nutcrackers and Gray Jays. These birds fly around the picnic tables picking up food scraps.

Canada

Bonaventure Island

This island in Quebec is the site of a large Northern Gannet rookery. It is accessible only by boats, which make the 15-minute trip from Percé several times a day. Visitors must hike for about 45 minutes to get to the nesting area. Birds can easily be photographed on the ground or in flight. Nesting occurs from June through September.

Fort Erie

Tens of thousands of gulls congregate along the Niagara River in the vicinity of Niagara Falls during late fall and early winter. Most are Bonaparte's, Ring-billed, Great Black-backed, and Herring gulls. Black-legged Kittiwakes and Sabine's, Franklin's, and Little gulls and other rarities are occasionally found. Most observation points along the river are at the top of the gorge, where cameras are of little value. At Fort Erie, on the Canadian side, the road runs along the riverbank. Gulls often feed right near the shore.

Point Pelee

Point Pelee, on the northern shore of Lake Erie in Ontario, is a great birding spot during spring and fall migrations. Because it juts out into Lake Erie, it is a natural attraction for migrating birds looking for a place to rest before or after their long flights over the lake.

WAYS TO GET CLOSE TO BIRDS

This table lists recommended methods of getting close to different birds to photograph them.

Keep in mind that these recommendations are quite subjective. For example, a particular bird species might be very approachable in one area and less so in other places. Photography at nests is dependent on first being able to find a nest that is accessible. In general, if a bird can be attracted with food, that will be the best way to get close to it for photography. If a bird is not too secretive or shy, then stalking may work well. Otherwise, you may have to find a nest or use a recording to get close-up pictures of the bird.

AlbatrossNest
AnhingaStalk
Ani .Stalk
AukletNest
AvocetStalk
BecardStalk
BitternStalk
BlackbirdStalk
Blackbird, Red-winged . . .Recording
BluebirdNest
BobolinkStalk
BobwhiteFood
BoobyNest
BulbulStalk
BuntingStalk
BushtitStalk
CaracaraStalk
CardinalFood
CatbirdRecording
ChachalacaFood
ChatNest
ChickadeeFood
Chuck-will's-widowStalk
CootStalk
CormorantStalk

CowbirdFood
CraneStalk
CreeperStalk
CrossbillFood
CrowStalk
CuckooStalk
CurlewStalk
DickcisselFood
DipperStalk
DoveFood
DowitcherStalk
Duck (diving)Stalk
Duck (surface feeding) . . .Food
DunlinStalk
EagleStalk
EgretStalk
FalconNest
FinchFood
FlamingoStalk
FlickeNest
FlycatcherStalk
FrigatebirdNest
FulmarNest
GallinuleStalk
GannetNest
GnatcatcherRecording
GodwitStalk
GoldfinchFood
GooseStalk
GrackleFood
GrebeStalk
GrosbeakFood
GrouseLek
GuillemotNest
GullFood
HawkStalk
HeronStalk
HummingbirdFood
Ibis .Stalk
JacanaStalk
JaegerStalk
Jay .Food
JuncoFood
KestrelNest box
KilldeerNest
KingbirdStalk

Kingfisher	Stalk	Redstart	Nest
Kinglet	Stalk	Roadrunner	Stalk
Kiskadee	Stalk	Robin	Stalk
Kite	Stalk	Ruff	Stalk
Kittiwake	Nest	Sanderling	Stalk
Knot	Stalk	Sandpiper	Stalk
Lapwing	Stalk	Shearwater	Stalk
Lark	Nest	Shrike	Stalk
Limpkin	Stalk	Siskin	Food
Longspur	Stalk	Skimmer	Stalk
Loon	Stalk	Snipe	Stalk
Magpie	Stalk	Solitaire	Stalk
Martin	Nest	Sparrow	Food
Meadowlark	Stalk	Sparrow, House	Food
Mockingbird	Stalk	Spoonbill	Stalk
Moorhen	Stalk	Starling	Food
Murre	Nest	Stilt	Stalk
Murrelet	Nest	Surfbird	Stalk
Nighthawk	Nest	Swallow	Nest
Nutcracker	Food	Swan	Stalk
Nuthatch	Food	Swift	Nest
Oriole	Nest	Tanager	Nest
Osprey	Nest	Tern	Stalk
Ovenbird	Nest	Thrasher	Stalk
Owl	Recording	Thrush	Stalk
Oystercatcher	Stalk	Titmouse	Food
Partridge	Food	Towhee	Stalk
Pauraque	Stalk	Trogon	Nest
Pelican	Stalk	Tropicbird	Nest
Petrel	Stalk	Turkey	Recording
Pewee	Nest	Turnstone	Stalk
Phalarope	Stalk	Veery	Nest
Pheasant	Food	Verdin	Stalk
Phoebe	Nest	Vireo	Nest
Pigeon	Food	Vulture	Stalk
Pipit	Stalk	Warbler	Nest
Plover	Stalk	Waterthrush	Stalk
Poorwill	Stalk	Waxwing	Stalk
Ptarmigan	Stalk	Whimbrel	Stalk
Puffin	Nest	Whip-poor-will	Stalk
Pyrrhuloxia	Food	Willet	Stalk
Quail	Food	Woodcock	Stalk
Rail	Stalk	Woodpecker	Food
Raven	Stalk	Wren	Nest
Razorbill	Nest	Wrentit	Nest
Redpoll	Food	Yellowlegs	Stalk

RECOMMENDED FOOD AND FEEDERS

Bird	Food	Feeder
Blackbird	Cracked Grain, Millet	Ground or Hanging
Bluebird, Eastern	Peanut Butter Mix, Dried Fruit	Hanging (winter)
Bunting, Indigo	Millet	Ground or Hanging
Bunting, Lazuli	Millet	Ground or Hanging
Cardinal	Sunflower Seeds	Ground or Hanging
Catbird	Oranges, Raisins	Ground
Chickadee	Sunflower Seeds, Suet	Hanging
Cowbird	Cracked Grain, Millet	Ground or Hanging
Creeper	Suet, Peanut Butter Mix	Spread on Tree Bark
Crossbill	Sunflower Seeds	Hanging
Crow	Cracked Grain	Ground
Dove	Cracked Corn, Millet	Ground
Finch	Sunflower Seeds, Millet	Hanging or Ground
Flicker	Suet, Peanut Butter Mix	Ground (winter)
Goldfinch	Niger Seed	Hanging
Grackle	Cracked Grain	Ground or Hanging
Grosbeak, Black-headed	Sunflower Seeds	Hanging (winter)
Grosbeak, Evening	Sunflower Seeds	Hanging or Ground
Grosbeak, Rose-breasted	Sunflower Seeds	Hanging
Grouse	Cracked Corn, Soybeans	Ground
Hummingbird	Sugar Water	Hanging
Jay	Whole Peanuts, Sunflower Seeds	Hanging or Ground
Junco	Millet	Ground
Mallard	Cracked Corn, Bread	Near/On Shore
Meadowlark	Cracked Grain	Ground
Mockingbird	Raisins, Suet	Ground
Nutcracker, Clark's	Suet, Bread, Peanuts	Ground
Nuthatch	Suet, Sunflower Seeds	Hanging
Oriole	Sugar Water, Oranges	Hanging
Pheasant	Cracked Corn, Soybeans	Ground
Pigeon	Cracked Corn, Millet	Ground
Quail	Cracked Corn, Soybeans	Ground
Redpoll	Niger Seed, Millet	Hanging or Ground
Robin	Sliced Apples, Peanut Butter	Ground
Siskin	Niger Seed, Millet	Hanging or Ground
Sparrow, House	Millet, Cracked Corn	Ground or Hanging
Sparrow	Millet, Cracked Corn	Ground
Starling	Suet, Bread Crumbs	Ground or Hanging
Tanager	Sugar Water, Suet	High Hanging
Thrush, Hermit	Raisins, Suet	Ground, Low Pltfrm.
Titmice	Sunflower Seeds, Suet	Hanging
Towhee	Millet, Cracked Corn	Ground
Turkey	Cracked Corn	Ground
Warbler, Yellow-rumped	Suet, Peanut Butter Mix	Platform (winter)
Woodpecker	Suet, Peanut Butter Mix	Attached to Tree Trunk
Wren, Carolina	Suet, peanut hearts	Hanging

EQUIPMENT

Camera Bag Essentials

camera bag lined with foam rubber
 compartments
camera body with body cap and neck strap
favorite lenses with lens caps
lens hoods
handheld exposure meter
film of various ISO ratings or digital cards
 for digital cameras
air blower brush
lens cleaner solution and lens tissue wipes
tripod, monopod, and/or bean bags
gaffer's tape
electronic flash
extra camera, exposure meter,
 and flash batteries
remote release
equipment manuals

Options

binoculars
spotting scope
filters such as UV haze, skylight 1A, polar-
 izing, neutral density, graded neutral den-
 sity, light amber, light blue
plastic bag or sheet to protect equipment
 in wet weather
soft absorbent towel or chamois
silica gel for wet weather
large umbrella
cooler and freezable gel packs
 for hot weather
extra camera body
extra electronic flash
extra handheld exposure meter
selenium cell exposure meter that operates
 in cold weather
notebook and permanent marker
self-stick labels to identify film
sunglasses
head and wrist sweat bands
camouflage clothing
gray card
resealable plastic bags for storing film
customized diopter to match your
 eyeglass prescription
reflectors
slave units and radio transmitter for

electronic flash
extension tubes
teleconverters
film x-ray bag for air travel

Tool Kit

film changing bag
film leader retriever
Swiss army knife
filter wrench
small socket wrenches
jeweler's screwdrivers
tweezers
needle-nosed pliers to loosen jammed
 tripod joints
pencil eraser to clean connections

Safety Kit

flashlight
compass
whistle
water
snacks
first aid kit
reflective tape for clothing during
 nighttime shooting

WEB SITES

The Web provides a great resource for
photographers. Most photographic
magazines have Web sites, as do photo-
graphic agencies and individual photogra-
phers. You can join discussion groups,
read articles by and about photographers,
view a wealth of images. If you are traveling
you can check the weather. The following
is a partial list of Web sites to get you
started. Remember that sites can change
or even disappear. There's no substitute
for surfing.

General

American Society of Media Photographers
 http://www.asmp.org
BestStuff.com
 http://www.beststuff.com
Eastman Kodak Co.
 http://www.kodak.com

North American Nature Photography
Association
http://www.nanpa.org
National Audubon Society
http://www.audubon.org
National Geographic Society
http://www.nationalgeographic.com
National Geographic Photography
Newsletter
http://www.nationalgeographic.com/
photography/
National Wildlife Federation
http://www.nwf.org
National Wildlife Refuge System
http://www.bluegoose.arw.r9.fws.gov/

Birding Web Sites

http://www.abcbirds.org
http://www.americanbirding.org
http://www.audubon.org
http://www.birding.about.com
http://www.birding.com/top100.htm
http://www.petersononline.com/
birds/links/general.html
http://www.birds.cornell.edu
http://www.virtualbirder.com/birder/
http://www.wildbirds.com
http://www.wildlifephoto.net/linls.html

Photo Books and Magazines Online
Books:

Amazon
http://www.amazon.com
Barnes and Noble
http://www.barnesandnoble.com
Buy.Com
http://www.us.buy.com/retail

Magazines:

Outdoor Photographer magazine
http://www.outdoorphotographer.com
Popular Photography magazine
On AOL only; keyword: POP PHOTO
Shutterbug magazine
http://www.shutterbug.net

MAGAZINES AND BOOKS

Photography Magazines

American Photo. Bimonthly publication
with features on professional
photographers, photography innovations,
and equipment reviews.
Nature Photographer. Quarterly magazine
about nature photography.
Outdoor Photographer. Ten issues per year.
Covers all aspects of photography out-
doors, with articles about professional
photographers, equipment, technique.
Petersen's PHOTOgraphic. Monthly publica-
tion covering all facets of photography.
Photo Techniques. Monthly magazine dedi-
cated to equipment, film, and darkroom
coverage.
Popular Photography. Monthly publication
covering all facets of imaging from con-
ventional photography to digital. Heavily
equipment oriented, with comprehensive
test reports.
Shutterbug. Monthly publication covering all
facets of photography from conventional
to digital. Also includes numerous ads for
used and collectible photo equipment.

Birding Magazines

Birding. American Birding Association
monthly publication.
Birder's World. Bimonthly publication for
casual birdwatchers to serious birders
including identification tips, photography
pointers, advice for traveling birders, and
more. (http://www.birdersworld.com)
Bird Watcher's Digest. Bimonthly magazine
for backyard as well as experienced bird-
ers. (http://www.birdwatchersdigest.com)
WildBird. Bimonthly magazine for birders.
(http://www.animalnetwork.com/wildbird)
Living Bird. Quarterly magazine of the Cor-
nell Laboratory of Ornithology.

General Photography Books

Peter K. Burian, Editor, *Camera Basics*,
Eastman Kodak, Silver Pixel Press.
Debbie Cohen, *Kodak Professional
Photo-guide*, Tiffen.
Derek Doeffinger, *The Art of Seeing*, Kodak
Workshop Series, Tiffen.
Eastman Kodak Co., *Kodak Guide to 35mm
Photography*, Tiffen.
Eastman Kodak Co., *Kodak Pocket
Photo-guide*, Tiffen.

Lee Frost, *The Question-and-Answer Guide to Photo Techniques,* David & Charles.
Tom Grimm and Michele Grimm, *The Basic Book of Photography,* 4th ed., Plume.
John Hedgecoe, *The Photographer's Handbook,* Alfred A. Knopf.
John Hedgecoe, *John Hedgcoe's Complete Guide to Photography,* Sterling.
Kodak, *How To Take Good Pictures,* Ballantine Publishing Group.

Birding Photography Books

Tim Fitzharris, *Wild Bird Photography:* National Audubon Society, Firefly Books.
Tim Gallagher, *Wild Bird Photography,* Lyons and Burford.
Arthur Morris, *The Art of Bird Photography: The Complete Guide to Professional Field Techniques,* Amphoto.
Arthur Morris, *Bird Photography: Pure and Simple,* Arthur Morris Birds as Art.
Larry West and Julie Ridl, *How to Photograph Birds,* Stackpole Books.

Bird Field Guides

Roger Tory Peterson, *A Field Guide to the Birds: A Completely new Guide to All the Birds of Eastern and Central North America,* Houghton Mifflin Co.
Roger Tory Peterson, *A Field Guide to Western Birds,* Houghton Mifflin Co.
National Geographic Society, *Field Guide to the Birds of North America,* 4th edition.
National Geographic Guide to Birdwatching Sites: Eastern U.S.
National Geographic Guide to Birdwatching Sites: Western U.S.

Birding Newsletters

National Geographic BirdWatcher. Bimonthly publication of the National Geographic Society.
Winging It. Monthly newsletter for American Birding Association Members.
Backyard Bird News. Bimonthly publication of Bird Watcher's Digest.

Birding Photography Video

Basics of Bird Photography (55 minutes) Rue Video.

Birding Travel Tours

Victor Emanuel Nature Tours
2525 Wallingwood Drive, Suite 1003
Austin, Texas 78746
800-328-8336
www.ventbird.com
Wings
1643 N. Alvernon, Suite 105
Tucson, Arizona 85712
888-293-6443
www.wingbirds.com
Field Guides Incorporated
9433 Bee Cave Road
Austin, Texas 78733
800-728-4953
www.fieldguides.com

Rulon Simmons, an image scientist at Eastman Kodak, has written and photographed for *Popular Photography,* Kodak's *Viewpoints* magazine, *Birds and Blooms,* and *National Geographic BirdWatcher.* His work has also appeared in the books *Winning Pictures* and *Applied Photography.* His photography has won numerous competitions in the United States and abroad. He lives in Rochester, New York.

Bates Littlehales began profiling birds in 1975 while working on a National Geographic magazine article on John James Audubon. Since then he has captured birds in still photography and video. His photographs have appeared in more than 60 publications, including *National Wildlife, Natural History, Birder's World, The Nature Conservancy, National Parks,* and *American Heritage.* His books include *Wetlands of North America, Bird Watch, Wild Southlands,* and The Atlantic Coast and Blue Ridge books in the Smithsonian Guides to Natural America series. He divides his time between the mountains of West Virginia

Boldface indicates illustrations.

National Geographic Photography Field Guide Birds

Rulon E. Simmons with Bates Littlehales

Published by the National Geographic Society

John M. Fahey, Jr., *President and Chief Executive Officer*

Gilbert M. Grosvenor, *Chairman of the Board*

Nina D. Hoffman, *Executive Vice President*

Prepared by the Book Division

Kevin Mulroy, *Vice President and Editor-in-Chief*

Charles Kogod, *Illustrations Director*

Marianne R. Koszorus, *Design Director*

Staff for this Book

Barbara Brownell, *Project Editor*

Charles Kogod, *Illustrations Editor*

Rebecca Beall Barns, *Text Editor/Researcher*

Cinda Rose, *Art Director*

Alexandra Littlehales, *Designer*

Rebecca Lescaze, *Contributing Editor*

Bob Shell, *Technical Consultant*

Jerry Jackson, *Consulting Ornithologist*

R. Gary Colbert, *Production Director*

Meredith C. Wilcox, *Illustrations Assistant*

Melissa Hunsiker, *Assistant Editor*

Manufacturing and Quality Control

Christopher A. Liedel, *Chief Financial Officer*

Phillip L. Schlosser, *Managing Director*

John T. Dunn, *Technical Director*

Vincent P. Ryan, *Manager*

Clifton M. Brown, *Manager*

One of the world's largest nonprofit scientific and educational organizations, the National Geographic Society was founded in 1888 "for the increase and diffusion of geographic knowledge." Fulfilling this mission, the Society educates and inspires millions every day through its magazines, books, television programs, videos, maps and atlases, research grants, the National Geographic Bee, teacher workshops, and innovative classroom materials.

The Society is supported through membership dues, charitable gifts, and income from the sale of its educational products. This support is vital to National Geographic's mission to increase global understanding and promote conservation of our planet through exploration, research, and education.

For more information, please call 1-800-NGS LINE (647-5463) or write to the following address:

National Geographic Society
1145 17th Street N.W.
Washington, D.C. 20036-4688 U.S.A.

Visit the Society's Web site at www.nationalgeographic.com.

FRONT COVER: A Great Blue Heron stalks its prey as the sun sets on Blackwater National Wildlife Refuge.

Bates Littlehales

Library of Congress Cataloging-in-Publication Data

Simmons, Rulon E.
National Geographic photography field guide—birds : secrets to making great pictures / Rulon E. Simmons and Bates Littlehales.
p. cm. ISBN 0-7922-6878-4
1. Photography of birds. I. Title: Photography field guide—birds. II. Littlehales, Bates.III. National Geographic Society (U.S.) IV. Title.

TR729.B5 S544 2002
778.9'328—dc21 2002033801